Lukas Feireiss

MEM(

C000053806

OF THE
MOON AGE

Spector Books

FOREWORD

For centuries mankind has been fascinated by space travel and exploring other planets. Long before engineers and scientists took the possibility of traveling to the Moon seriously virtually all of its aspects were first explored in art and literature.

Our nearest astronomical neighbor, the Moon—just three days away by rocket—still serves as an object of creative projection and speculation to visionaries across the globe. After nearly five decades since the first moonwalk, this little book attempts to trace a visual cultural history of lunar exploration from past, to present, and future. This inspiring journey through history ranges from Ptolemy's early calculations of the distance to the Moon, Galileo Galilei's invention of the telescope and his pen drawings of the lunar surface, to fictional Moon travels from Johannes Kepler, Cyrano de Bergerac, Edgar Allen Poe, Jules Verne, and Stanislav Lem. The book also pays tribute to the pioneers of rocket-science such as Max Valier, Hermann Oberth, and Wernher von Braun, the congenial bond of art, commerce and science during the golden age of space travel in the mid 20th century to NASA's Apollo 11 Moon landing, all the way to contemporary enterprises in lunar travel and construction from Virgin Galactic to Foster + Partners.

Memories of the Moon Age explores space travel to the Moon as the ultimate flight of fancy for the human imagination and testing ground for ideas in reality. The artist book at hand is thereby at once a

copy, a combination, and a creation. A critical cut-up, a playful montage that devotes itself to freely referencing and reorganizing a multitude of images and narratives deriving from a vast pool of visual culture.

The images for this rather specific cultural inquiry on lunar space travel were chosen after extensive research in books and on the internet, just as the writing has emerged from numerous readings and recombinations of texts.

By exploring new possibilities of storytelling the book aims to cultivate a heightened sense of contemporary cultural reflexivity. Through the precarious process of selecting and showing images, reading and writing text, it encourages its readers to find, learn, enjoy and celebrate experimental forms of creative production and reception today.

Lukas Feireiss

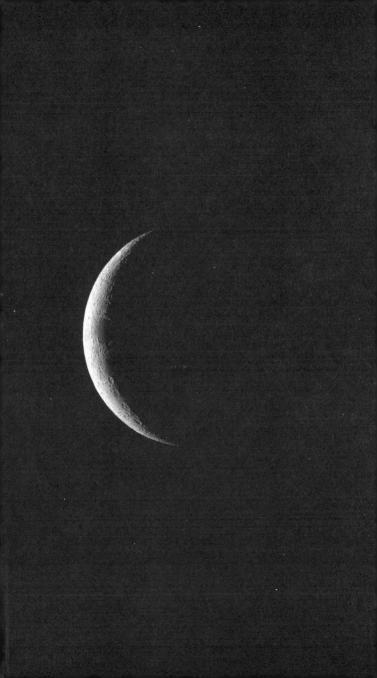

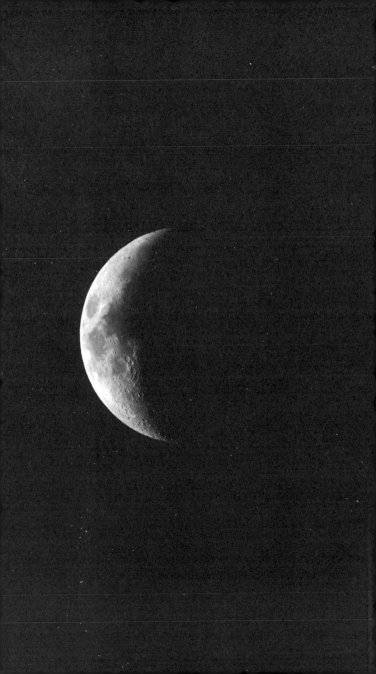

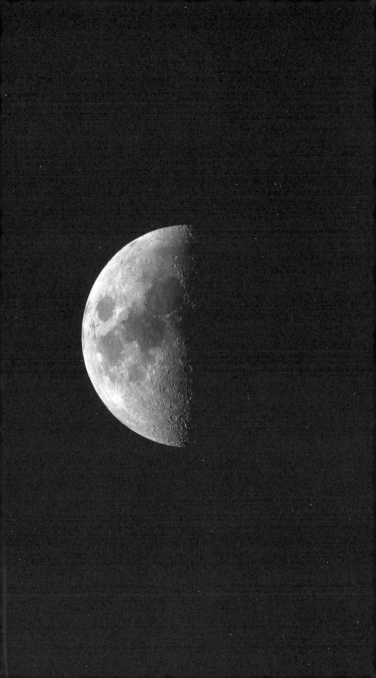

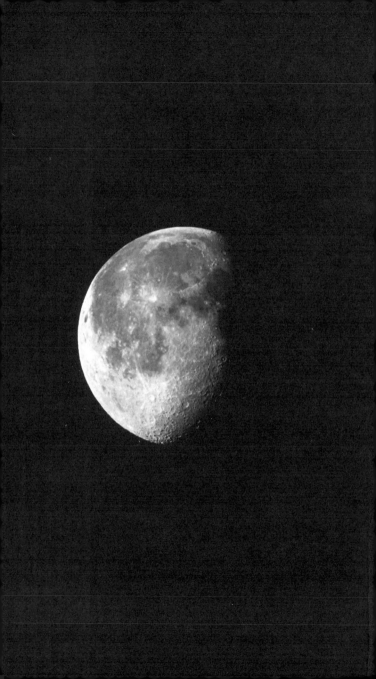

EVERY CULTURE TOGETHER

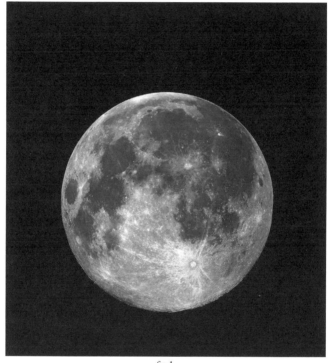

fig. 1

Since the dawn of time the Moon has been present in every culture. Together with the Sun it is the only object in the sky that everyone can recognize. From the age of one, a baby can already recognize the Moon, while only a small percentage of the total population are able to recognize any other celestial body in the firmament.

9

EIGHTH CONTINENT

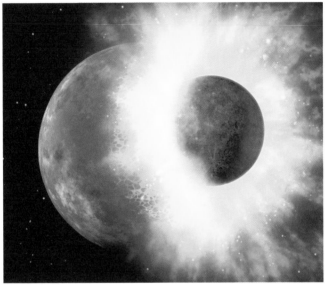

fig. 2

From what we know, the Moon was formed 4.5 billion years ago when an "embryo" of a planet impacted young Earth that was around 30 to 50 million years old at the time. This impact created a cloud of debris that re-condensed and formed the Moon.

In that sense the Moon is not actually another world as it was created from our Earth. The Moon is our planet's eighth continent. From observing the Moon we can understand the environment of the Earth in its early infancy. The Moon has retained a memory from this very early time of the Solar System.

When the Moon was formed it was far closer to the Earth, almost 20 times closer than at present. The tidal forces affected the early geological magmatic evolution of Earth. The Moon still maintains a strong influence on our planet. Thanks to the Moon, the Earth's orientation remains stable. If we did not have a Moon, Earth's axis of rotation would fluctuate in all directions.

For millennia the Moon has been carefully observed. From excavated tally sticks, researchers have deduced that people counted days in relation to the Moon's phases as early as the Paleolithic Age. In the first millennium BC, Babylonian astronomers in Mesopotamia studied the cycles of the Moon in great detail. It was then that a month, as a unit of time used with calendars, was first used and conceived as a natural period related to the motion of the Moon. The term "month" etymologically derives from the word "Moon".

HOT ROCK

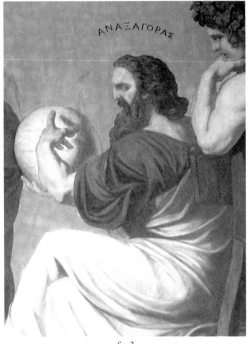

fig. 3

In the fourth century BC the ancient Greek philosopher, Anaxagoras, reasons that the Moon is a giant spherical rock that shines due to reflected light from the Sun: "Everything has a natal explanation. The Moon is not a god, but a great rock, and the Sun a hot rock." He also says that the Moon has mountains and believes that it is inhabited. His controversial theory is one of the causes of his imprisonment and eventual exile.

12

BOUNDARY BETWEEN SPHERES

fig. 4

Approximately a century later the Greek philosopher, proto-scientist, and tutor of Alexander the Great, Aristotle, marks the Moon as the boundary between the spheres of the mutable earth and the imperishable stars of ether in his description of the universe. According to Aristotle, the first being belongs to the realm of change and corruption, the latter to the realm of heavenly perfection.

EARLY LUNAR OBSERVATIONS

fig. 5

The first human to correctly theorize on the Moon's influence on Earth's tidal forces was the Hellenistic astronomer and philosopher, Seleucus of Seleucia in the second century BC. In the following centuries various attempts were made to calculate the size and distance of the Moon from the Earth. However, the first person to come close to the correct values was the Greco-Roman writer of Egypt, Ptolemy in the first century AD. His mathematical and astronomical treatise on the apparent motions of the stars and planetary paths, *Almagest,* is one of the most influential scientific texts of all time and has had wide and long-lasting recognition and influence for over a millennium.

14

ORB OF THE MOON

Ta sage instruction sert de riche couronne
A Trajan, esleué par dessus tous humains.
Si les grands te portoient au cœur & dans leurs mains,
Vertu viuroit au lieu de Venus & Bellone

fig. 6

Greek-Roman historian, Plutarch (46–120 AD), proclaims in *De facie in orbe lunae* (On the Face which Appears in the Orb of the Moon) that the Moon is similar to the Earth, though smaller, and is inhabited by a species of intelligent beings. He believes that before being born and after death souls may wonder off to the Moon and gaze upon its mysteries. Furthermore, Plutarch suggests that the Moon shines by reflected sunlight and that it revolves around the Earth as the Earth revolves around the Sun—a theory almost unique in his day.

15

TRUE HISTORY

Subsequently, in the second century AD, Assyrian rhetorician and satirist, Lucian of Samosata creates his fictional narrative work entitled, *Vera Historia (True Story)*, the first imaginary voyage to the Moon. The

fig. 7

fig. 8

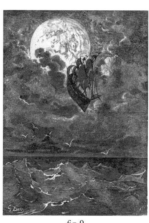

fig. 9

work already offers the essential ingredients of inter-galactic fiction: 50 Greek athletes journey in a sailing vessel, the ship lands, and there are descriptions of adventure on the Moon, the story ends with a safe return passage back home to Earth. Furthermore, Lucian contemplates extraterrestrial life and even wars between planets, nearly two millennia before Jules Verne. In his mixture of speculation and storytelling Lucian thereby anticipates the genre of science fiction.

MARVELOUS FLIGHT

fig. 10

Centuries pass without any repetition of similar adventures in world literature. Then in 1010 CE, Persian poet, Ferdowsi outlines a marvelous flight into the heavens and the Moon, in his legendary history of Persia. No tales of travel to the Moon exist that were written during medieval times in Europe. Generally speaking, until the Middle Ages, the Moon remained an untouchable, unspoiled object of the divine in ancient mythology and religious belief systems spanning across the globe.

HILAL

In the Islamic world, the Moon plays a significant role because of the use of a lunar calendar to determine the date of Ramadan. The appearance of the lunar cres-

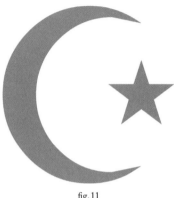

fig. 11

cent, known as "Hilal," was proclaimed to the people, as it defines the start and end of Islamic months. The need to determine the precise time of the appearance of the lunar crescent was one of the inducements for Muslim scholars to study astronomy.

IMMACULATE

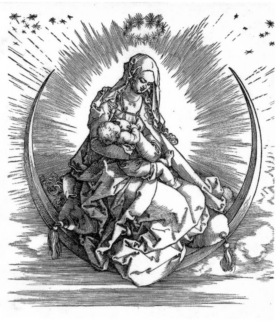

fig. 12

The immaculate connotation of the Moon also has a rich iconographic history in Western Culture. The Roman Catholic Virgin Mary is pictured with the Moon under her feet. As in Revelation 12:1–2 in the Bible, where it is written: "A great and wondrous sign appeared in heaven: a woman clothed with the sun, with the moon under her feet and a crown of twelve stars on her head. She was pregnant and cried out in pain as she was about to give birth."

WOUNDED SNAKE

In 1178, around five monks from Canterbury reported an upheaval on the Moon shortly after sunset. "There was a bright new Moon, and as usual in that phase its horns were tilted toward the east; and suddenly the upper horn split into two. From the midpoint of this division a flaming torch sprang up, spewing out, over a considerable distance, fire, hot coals, and sparks. Meanwhile the body of the Moon, which was below

fig. 13

writhed, as it were, in anxiety, and, to put it in the words of those who reported it to me and saw it with their own eyes, the Moon throbbed like a wounded snake. Afterwards it resumed its proper state. This phenomenon was repeated a dozen times or more, the flame assuming various twisting shapes at random and then returned to normal. Then, after these transformations, the Moon from horn to horn, that is along its whole length, took on a blackish appearance."

20

ECLIPSE

fig. 14

In an effort to persuade the natives of Jamaica to continue providing for him and his hungry men, the Italian explorer and discoverer of the American continents, Christopher Columbus, successfully intimidates the natives by correctly predicting a lunar eclipse in 1504, using the celestial navigation tables and values of the German astronomer, Regiomontanus.

ORLANDO FURIOSO

In the Italian poet, Ludovico Ariosto's book *Orlando Furioso* (1532), St. John the Evangelist proposes to Astolpho that he, "…a flight more daring take/To yonder Moon, that in its orbit rolls,/The nearest planet to our earthly poles." Aphostolo travels to the Moon in a chariot drawn by four red horses in the quest for the lost mind of Orlando. The Moon possesses many of the natural features of the Earth including cities, towns, and castles.

GREAT COMET

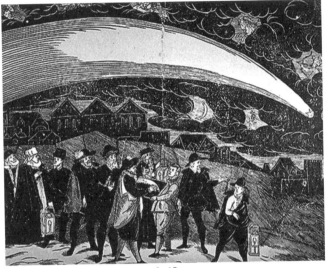

fig. 15

A comet that passes close to Earth in the year 1577 is viewed by many people all over Europe and has a profound influence on the field of astronomy. The comet is seen by many astronomers, including the famous Danish astronomer, Tycho Brahe. Johannes Kepler—then only six years old—was introduced to astronomy that year by the passing of the Great Comet.

GALILEO'S TELESCOPE

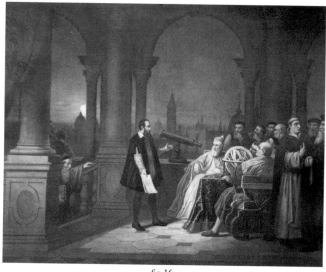

fig. 16

One of the most important events in the history of Moon flight, however occurred in the early sixteenth century, when Italian physicist, mathematician, astronomer, and philosopher Galileo, hailed as the "father of modern physics," first turned his improved telescope towards the Moon and discovered that the Earth's natural satellite was a world in its own right. In his book *Sidereus Nuncius*, published in 1609, Galileo drew one of the first telescopic drawings of the Moon with its characteristic mountains and craters. A 16 km long crater on the Moon is named after him.

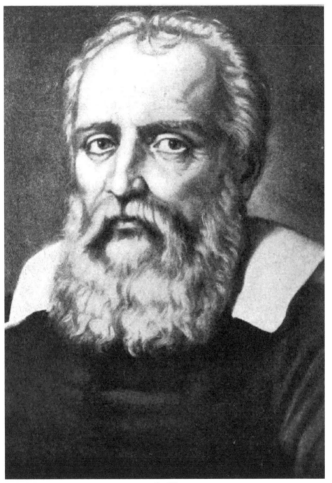

fig. 17

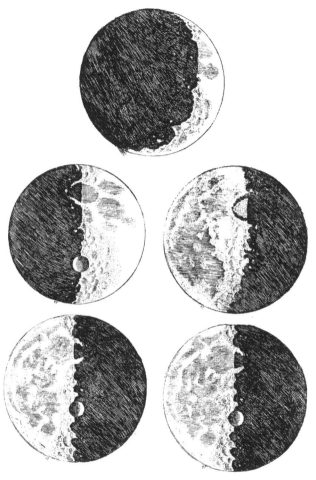

fig. 18

CARTOGRAPHY OF THE MOON

The first map of the Moon was drawn up in 1645 by the Belgian cosmographer and astronomer, Michael van Langren. Two years later, the astrono-

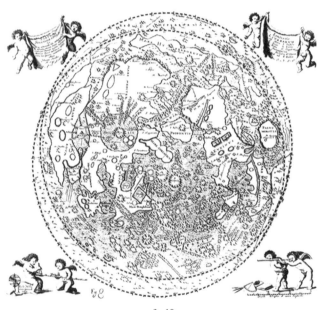

fig. 19

mer, Johannes Hevelius published a far more significant cartography of the Moon. In 1647, Hevelius published *Selenographia,* which was the first treatise entirely devoted to the Moon.

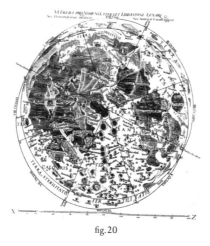

fig. 20

Later, in the seventeenth century, the Jesuit astronomer, Giovanni Battista Riccioli and Francesco Maria Grimaldi together drew another map of the Moon that named numerous craters after philosophers and astronomers, which remain as the recognized names to this day.

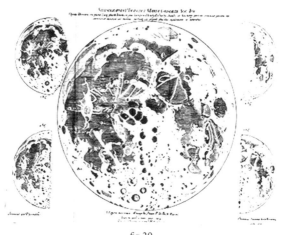

fig. 20

27

NEW WORLDS

At about the same time that Galileo and his fellow astronomers were discovering new worlds in our solar system, other explorers were finding new worlds on the other side of the Atlantic Ocean. The Moon was given an equivalent status among the other newly discovered continents such as North and South America.

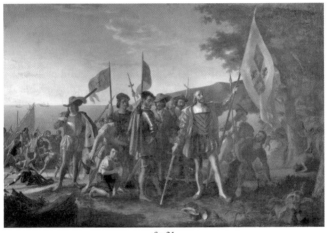

fig. 21

Now that humankind has learned that there are not only new worlds here upon Earth, but as yet unknown places in the sky as well, it is not surprising that discoveries being made by astronomers are followed by a yearning for extraterrestrial exploration expressed by an unprecedented wave of outer space travel stories. When we look skyward we now see worlds comparable to our own.

SOMNIUM

fig. 22

Born to a mercenary and an herbalist—who was later trialled for witchcraft—the German mathematician, astronomer, and astrologer, Johannes Kepler produced the first literary science fiction about the Moon since Lucian. In 1609 the *Somnium (Dream)* is composed as an allegory, footnoted between the early 1620s and 1630s, and published in 1634, four years after the author's death. This fantastic novel, written by the renowned astronomer, presents a detailed and imaginative description of how the Earth might look when viewed from the Moon, but it is also considered to be the first serious scientific treatise on lunar astronomy.

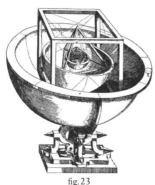

fig. 23

MAN IN THE MOONE

Along with Kepler's *Somnium,* the pseudonymously and posthumously published novel *The Man in the Moone* (1638) by the English bishop, Francis Godwin,

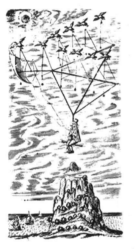
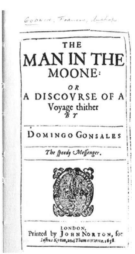

fig. 24

is also considered to be one of the earliest works in the science fiction genre. This fantastic voyage of utopian discovery tells the story of a man who flies to the Moon in a chariot towed by geese, where he encounters an advanced lunar civilization. Both books written by key figures of the seventeenth century scientific revolution had an enormous impact on the European imagination for centuries after their initial publication.

EMPIRES OF THE MOON

Although the envisioned methods of traveling to the Moon were highly unscientific, numerous other authors imagined trips to the Moon during the follow-

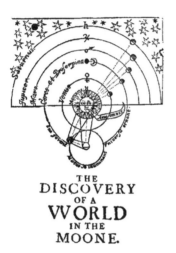

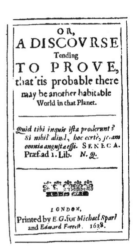

fig. 25

ing years. For instance, John Wilkins's *The Discovery of a World in the Moone* in 1638, which predicts a human colony on the Moon; or playwright, swordsman, and philosopher, Cyrano de Bergerac's *Comical History of the States and Empires of the Moon* in 1656. In the latter, de Bergerac tried to imagine as many utterly ridiculous methods of space travel as he could think of. Ironically, the method he thought would be the most outlandish was the use of rockets.

fig. 26

47 ROCKETS

fig. 27

While Galileo, Kepler, Godwin, and others fantasized about traveling to the Moon, a Chinese official by the name of Wan Hu attempted to launch himself into outer space on a chair to which 47 rockets were attached. On the appointed launch day, Wan, splendidly attired, climbed into his rocket chair, 47 servants lit the fuses and then hastily ran for cover to escape the huge explosion. After the smoke cleared, there was nothing at all left of poor Wan and his chair. The crater, Wan-Hoo, on the far side of the Moon is named after him.

LUNAR VOYAGES

THE
CONSOLIDATOR
OR,
MEMOIRS
OF
Sundry Transactions
FROM THE
World in the Moon.

Translated from the Lunar
LANGUAGE,

By the AUTHOR of
The True-born English Man.

LONDON:
Printed, and are to be Sold by *Benj. Bragg*
at the *Blue Ball* in *Ave-mary-lane,* 1705.

fig. 28

During the first years of the eighteenth century there were two more lunar voyages. The first is David Russen's *Iter Lunare: or a Voyage to the Moon* in 1703, in which the protagonist reaches the Moon by means of a curious spring device. Two years thereafter Daniel Defoe, author of *Robinson Crusoe*, provides another literary journey to the Moon in his work *The Consolidator.* In this book, Defoe recounts many legends of flights to the Moon and the means to get there; the most intriguing being an engine known as the "consolidator"—also the title of the publication.

34

LITERARY MOON TRIPS

Inspired by the frenzy surrounding a recent lunar eclipse, English satirical and political illustrator, William Hogarth creates *Royalty, Episcopacy, and Law / Some of the Principal Inhabitants of the Moon* around 1724. The engraving of the original painting is made later that century. In the flourishing text below the

fig. 29

fig. 30

image he explains the sudden clarity with which the Moon's surface and its inhabitants can be scrutinized by means of a telescope. Further volumes about voyages to the Moon are published; Samuel Brunt's *A Voyage to Cacklogallinia* (1727) and Murtagh McDermot's *A Trip to the Moon* (1728). Brunt's tale centers on that of an economically unsuccessful hunt for gold on the Moon, which is reached by bird power. McDermot's protagonist reaches the Moon by a sudden whirlwind and lands back on Earth with the force of a massive explosion of gunpowder.

MONTGOLFIER BROTHERS

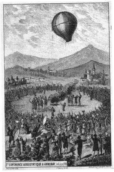

fig. 31

The next far-reaching event in the history of the popular conception of space travel occurred in 1783 when two French brothers, Étienne and Joseph Montgolfier, invented the hot-air balloon. If Galileo showed that there are other planets, the Montgolfier Brothers showed that the technology might exist for getting there. For the first time, human beings were able to ascend above Earth. This development resulted in masses of speculative literature about the possibility of traveling beyond Earth and theories as to what might be found on these new worlds—such as the Moon.

During an April night in 1787, the British astronomer, Sir William Herschel notices three red glowing spots on the dark side of the Moon. He informs King George III and other astronomers of his observations. Herschel attributes the phenomena to erupting volcanoes.

SURPRISING ADVENTURES

The BARON recovers his Hatchet.

fig. 32

The Surprising Adventures of Baron Munchhausen, a collection of outrageously far-fetched stories, published in the mid 1780s in both German and English includes two voyages to the Moon with a description of its flora and fauna. A few years later, in 1793, an anonymous British author writes *A Voyage to the Moon* under the nom de plume, Aratus.

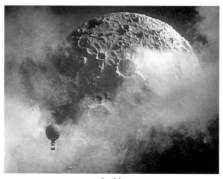

fig. 33

BETWEEN ROMANTICISM AND INDUSTRI- ALIZATION

At the same time, the Moon was placed as a core element in numerous esoteric practices.

The Hungarian astronomer and ordained Jesuit priest, Maximilian Hell (1720–1792), for example, thought that he could heal certain ailments by redirecting the forces of the Moon. The crater called "Hell" on the Moon is named after the priest.

In some ways this sets the tone for the coming nineteenth century, that started with Romanticism and ended with the Industrial Revolution. In this century our natural satellite continued to exert a great influence over the Earth and its inhabitants. In manifold ways poets, painters, and musicians have taken it as a source of inspiration. Moonlight produced an aesthetic of obscured vision and created a moment of altered subjectivity. During the late eighteenth and early nineteenth century transformation of the senses and lunar vision became a vehicle for deep travel into the self.

In his lengthy narrative poem, *Childe Harold's Pilgrimage*, the flamboyant English poet and leading figure in the Romantic Movement, Lord Byron describes the travels and reflections of a world-weary young man. In the first canto of his famous poem Byron

38

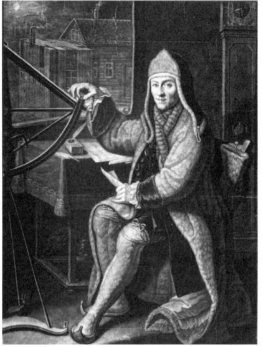

fig. 34

immortalizes a nocturnal Roman moonlit excursion, which heightens the sensibility and poetic charm of the narrator. Childe Harold intones, "The Moon is up, and it is not yet night" as the Roman ruins emerge into view at the twilight hour. The moonlight that Byron's hero admires influences his contemporaries.

Moonlight was also an aesthetic device to enhance the experience of the tourist, from castle ruins to mechanical dioramas. Louis-Jacques-Mandé Daguerre's oil painting, *The Ruins of Holyrood Chapel* (1824) depicted a popular tourist site. Moonlight tourism continued to retain an allure for a long time.

39

CONTEMPLATING THE MOON

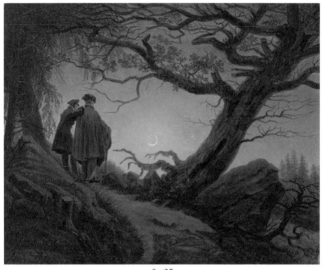

fig. 35

Caspar David Friedrich's famous painting, *Two Men Contemplating the Moon* from around 1819 depicts two men observing the waning Moon. The figures have been identified as Friedrich, himself, on the right and his talented young colleague, August Heinrich on the left. The mood of pious contemplation relates to the fascination with the Moon across all disciplines. Both figures are seen from behind so that the viewer can participate in their communion with nature, which the Romantics saw as a manifestation of the Sublime.

MOONLIGHT SONATA

fig. 36

Classical music also offers various references to moonlight. Ludwig van Beethoven's Piano Sonata No. 14 in C-sharp minor "Quasi una fantasia," Op. 27, No. 2, popularly known as the "Moonlight Sonata" completed in 1801, is one of Beethoven's most popular piano compositions. The popular title of "Moonlight Sonata" was not actually given until several year's after the composer's death. In 1836, the German music critic, Ludwig Rellstab wrote that the sonata reminded him of the reflected moonlight of Lake Lucerne. Since then, the "Moonlight Sonata" has remained the unofficial title of the sonata.

SUITE BERGAMASQUE

The influential French composer, Claude Debussy's famous piano composition, *Suite bergamasque* (1890) also includes a movement called "Clair de lune" (moonlight), which was probably directly inspired by the poem of the same title by French Symbolist poet, Paul Verlaine written in 1869. Yet one cannot be certain, as France's most famous poet and dramatist, Victor Hugo, also published a poem of the same name many years previously in his 1829 collection, *Les Orientales*. Furthermore, Guy de Maupassant, the father of the genre of modern short stories, published an entire collection of his stories under the same title *Clair de lune* in 1883.

SUITE BERGAMASQUE

PRÉLUDE

CLAUDE DEBUSSY
(1890)

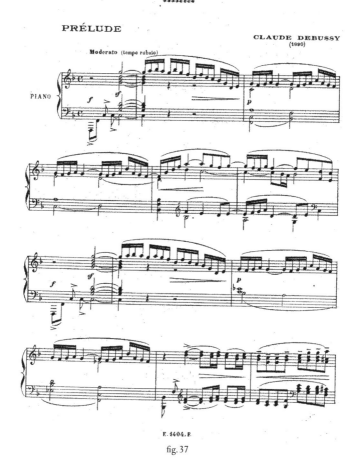

F. 1404. F.

fig. 37

MAPPA SELENOGRAPHICA

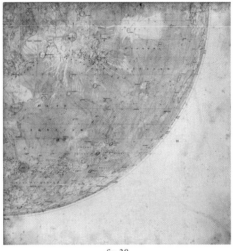

fig. 38

The most influential contribution to lunar topogra-
phy in the nineteenth century, however was a highly
detailed, large-scale lithographic map created by
Johann Heinrich von Mädler and Wilhelm Beer. In a
privately built observatory in Tiergarten Berlin, they
produced the first precise map of the Moon, entitled
Mappa Selenographica between 1834 and 1836. A year
later they publish a description of the Moon, *The Moon
According to Its Cosmic and Unique Relationships (Der
Mond nach seinen kosmischen und individuellen Verhält-
nissen)* that remains the most accurate description of
the Moon for many decades.

LUNARIANS

fig. 39

Only a few years earlier across the Atlantic, George Tucker, an American attorney, author, educator, and politician, using the pseudonym Joseph Atterly, writes the satire, *A Voyage to the Moon: With Some Account of the Manners and Customs, Science and Philosophy, of the People of Morosofia, and other Lunarians.* It is one of the earliest works of American science fiction. Tucker uses the relatively successful *Voyage* novel to ridicule the social manners, religions, and professions of some of his colleagues and to criticize some erroneous scientific methods and results apparent to him at the time.

GREAT MOON HOAX

fig. 40

Throughout the final week of August 1835, a long article appeared in serial form on the front page of the New York newspaper *The Sun,* about the supposed discovery of life and even civilization existing on the Moon. The articles described fantastic animals on the Moon, including bison, goats, unicorns, biped tail-less beavers, and bat-like winged humanoids called "Vespertilio-homo" who even built temples. The article describes the supposed discovery of trees, oceans, and beaches. These sightings were supposedly made with "an immense telescope of an entirely new principle" and falsely attributed to Sir John Herschel, perhaps the best-known astronomer of his time.

The authorship of the article, later known as "The Great Moon Hoax", was eventually attributed to Richard Adams Locke, a Cambridge-educated reporter who was working for *The Sun* at the time. This incident is

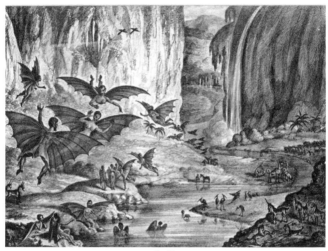

fig. 41

regarded as the first example of a large-scale and deliberate falsification in newspaper journalism. When *The Sun* acknowledged the hoax only a month later, the public reaction was mostly bemusement. Not least because of the circumstances of its publication, "The Great Moon Hoax" remains one of the most infamous in media history.

ONE HANS PFAALL

fig. 42

Already two months earlier American writer, Edgar Allan Poe–curiously enough a former student of the aforementioned George Tucker at the University of Virginia–published his own Moon hoax in the monthly magazine *Southern Literary Messenger* entitled "Hans Pfaall–A Tale", later republished as "The Unparalleled Adventure of One Hans Pfaall". Poe, known for his mysterious and macabre tales, also intended to continue the hoax in further installments, but was upstaged by the attention of Locke's "The Great Moon Hoax" in *The Sun*.

Poe's story describes the voyage to the Moon in a hot-air balloon, using a factually implausible scenario: Pfaall lives for five years on the Moon with "lunarians" and sends back a lunation to Earth. Even though Poe's frivolous tone in his story made it easy for educated readers to see through the supposed hoax, he paid more attention to science and technology than any other author had before him. It was the first time that someone had ever written about a journey to the Moon in such detailed terms, flawlessly mimicking the language of science.

For the first time it became necessary to provide an interplanetary story with seemingly plausible scientific evidence to make the narrative appear realistic, or plausible regardless of whether it is actually fictional or non-fictional. Many authors followed the moonlit path of science fiction by applying scientific principles to their fictional narratives in the following years, from John Leonard Riddell's highly condensed thought experiment, entitled, *Orrin Lindsay's Plan of Aerial Navigation, with a Narrative of his Explorations in the Higher Regions of the Atmosphere, and his Wonderful Voyage Round the Moon* (1847) or *The History of a Voyage to the Moon* by the pseudonymous and unidentified English author Chrysostom Trueman in 1865. The latter contains one of the most detailed descriptions of a spaceship in nineteenth century speculative literature and preceded the publication of Jules Verne's timeless space novels by a mere few months.

DRAPER'S PHOTOGRAPH

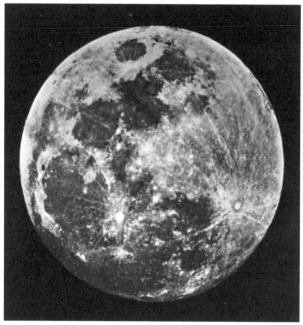

fig. 43

Apart from these fictional lunar depictions, the invention of photography in the early decade of the nineteenth century also has an impact on the depiction of the Moon, just as the new technology had on all forms of visual representation. The camera now captures more detail and information than traditional media, such as painting and sculpture. The American scientist, historian and photographer, William Draper, produces the first detailed photograph of the Moon in 1840.

MOON MODELS

fig. 44

Bringing the Moon even closer to home, James Nasmyth, a wealthy Scottish engineer and inventor dedicated to astronomy and photography, constructs highly detailed, three-dimensional models of the Moon's surface out of plaster in the early 1840s and then photographs the models. In 1874 he publishes a book entitled *The Moon: Considered as Planet, a World, and a Satellite* illustrated with his photographs.

fig. 45

51

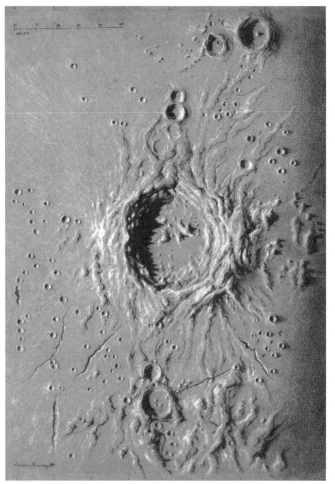

fig. 46

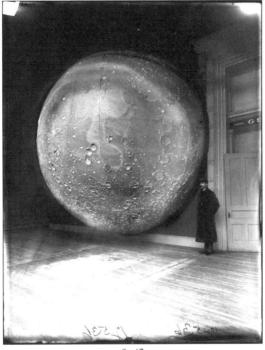

fig. 47

While Nasmyth works on his lunar models in Scotland, in Germany Thomas Dickert constructs an enormous hemispherical model of the Moon's visible side. The model is about 6 m (20 ft.) in diameter and is presented to the German public in the 1850s and is later exhibited in the United States.

FROM THE EARTH TO THE MOON

The true pioneer of the space age, despite the many predecessors, undoubtedly remains the French novelist, poet, and playwright, Jules Verne, with his seminal novel on space travel *From the Earth to the Moon* (1865) and its sequel *Around the Moon* (1870). Both books tell the story of the attempt to build an enormous skyward-facing space gun and to launch three people in a projectile with the goal of a Moon landing. The story then follows the three men in their travels from the Earth and around the Moon. Verne's rich imagination paired with his scientific exactitude has fueled the realms of both science and the arts ever since.

AROUND THE MOON

Verne's Moon-travel sequels help to develop Poe's approach of scientific semblance to a degree of reality that Poe never imagined to be possible. Verne considers the actual technological problems of spaceflight and saturated his books with so much science, math, and engineering that his nineteenth century readers accept his story without question, some even going so far as to write to the author volunteering to go in the projectile themselves!

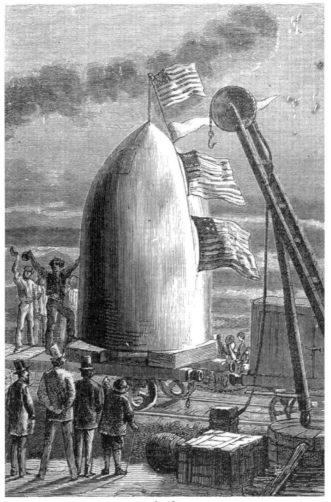

fig. 48

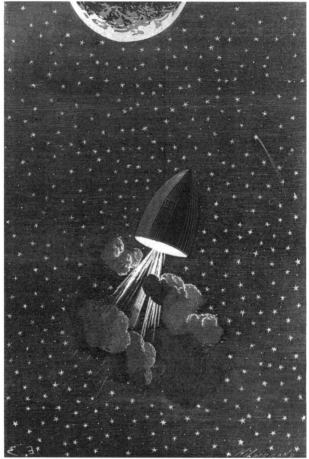

fig. 49

The optimism and belief in science and technology inherent in Verne's writing must be understood against the backdrop of the ongoing Industrial Revolution at the time. To the general public, virtually everything seems possible to achieve through science, engineering, and technological innovation. With the publica-

tion of Verne's novel, the possibility of spaceflight is instantly transformed from the realm of the fantastic to a mere exercise in Victorian engineering. Published all over the world, Verne's novels also directly inspire the early rocket scientists who set themselves to task, bringing to life what Verne had described in his writing.

BRICK MOON

fig. 50

Before space flight entered the realm of reality, other science fiction writers follow in the footsteps of Verne's interplanetary travels. American author, Edward Everett Hale's work of speculative fiction, *The Brick Moon* (1869), describes the construction and launch into orbit of a sphere made of bricks. In his story, the sphere is accidentally launched and the people aboard survive, thus providing the first known fictional description of a space station.

ANDRÉ LAURIE

CONQUEST OF THE MOON

The Mahdists were evidently disturbed.

Page 188.

fig. 51

In André Laurie's science fiction novel, *The Conquest of the Moon* (1888) the Moon is drawn from its orbit to land in the Sahara desert via giant electromagnets. "Laurie" was one of Paschal Grousset's pseudonyms. He was also a contemporary and occasional collaborator of Jules Verne.

ADVENTURES EXTRA-ORDINAIRES

fig. 52

Between 1888 and 1896, a quadruple-volume set of novels are published: *Adventures extraordinaires d'un savant Russe (The Extraordinary Adventures of a Russian Scientist)*, by Georges Le Faure and Henri de Graffigny. It is a veritable catalog of imaginative space-craft, ranging from "Vernian" projectiles and rockets, to solar sails. The four volumes deal with adventures on the Moon, other planets, comets, and asteroids.

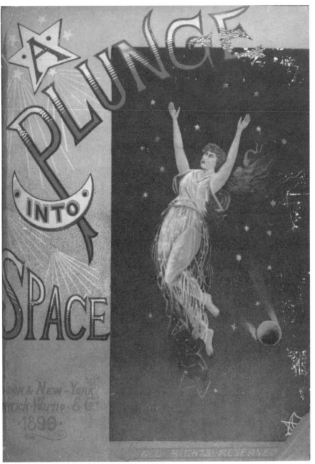

fig. 53

ROBERT CROMIE

PLUNGE INTO SPACE

THE LAST MAN ENTERS THE STEEL GLOBE.

Front.

fig. 54

Irish journalist and novelist, Robert Cromie's 1890 novel, *A Plunge Into Space* contains a detailed description of a spacecraft and a number of fascinating technological prophecies, such as televised broadcasts. Unlike most authors of interplanetary stories of his era, Cromie uses the Martian rather than the Lunar civilization as the focus of his novel. Cromie dedicates his book, *A Plunge Into Space* to Jules Verne to whom he felt "indebted from many delightful and marvelous excursions—notable a voyage from the earth to the moon." Verne also writes the foreword in Cromie's book.

61

KONSTANTIN TSIOLKOVSKY

DREAMS OF THE EARTH AND SKY

fig. 55

The reclusive Soviet pioneer of rocket science and astro-nautics, Konstantin Tsiolkovsky publishes *Dreams of the Earth and Sky* in 1895, which describes human-kind's settlement of Space, complete with characters who mine asteroids and build orbital greenhouses.

FIRST MEN IN THE MOON

fig. 56

fig. 57

Cromie's work predates H.G. Wells's *The First Men in the Moon* (1901) by a decade, but nevertheless contains a number of similarities. Cromie even accuses the English author of having plagiarized from his novel soon after the publication; an accusation that Wells denies. *The First Men in the Moon* is a science fiction romance that tells the story of a journey to the Moon undertaken by two protagonists, a businessman narrator and an eccentric scientist, who discover that the Moon is inhabited by a sophisticated extraterrestrial civilization of insect-like creatures they call "Selenites".

CINEMAGICIAN

Loosely based on Jules Verne's and H.G. Wells's Moon travel novels, the prolific French illusionist, innovator, and pioneer filmmaker, George Méliès translates the dream of manned space travel to the Moon into moving images in the earliest days of cinema. His 14-minute silent film, *A Trip to the Moon,* created in 1902 will become his most famous film. The film includes the

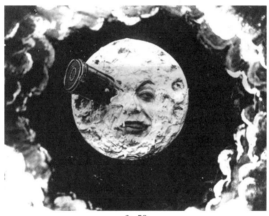

fig. 58

celebrated scene in which a spaceship hits the man on the Moon in the eye and stars Méliès, the "Cinemagician" himself as Professor Barbenfouillis, president of the Astronomer's Club and pilot of the rocket ship. The film shows an image of what the Earth might look like from the Moon.

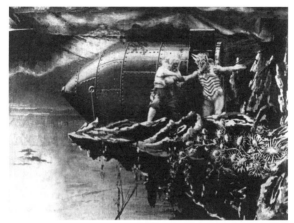

fig. 59

fig. 60

fig. 61

MOON ATLAS

Whilst Méliès fantasizes about the Moon on screen, French astronomers, Maurice Lœwy and Pierre-Henri Puiseux spend the years between 1894 and 1909 making a complete series of detailed photographs of the Moon and the lunar surface. Their *L'atlas photographique de la Lune* published in 1910 is considered to be the finest and most meticulous documentation of the Moon until the advent of space probes in the 1960s. In recognition of their discoveries, two of the moon's craters are named after Lœwy and Puiseux in honor of the astronomers.

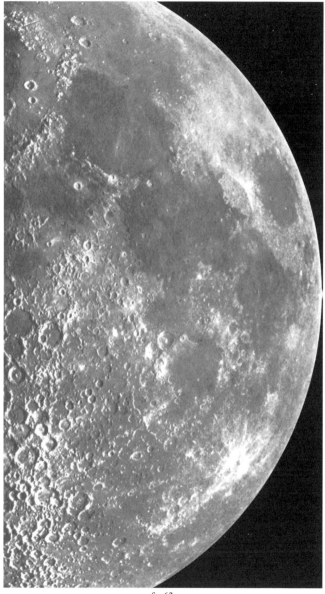

fig. 62

WRIGHT BROTHERS

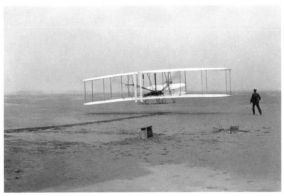

fig. 63

The Wright brothers, two American inventors and aviation pioneers build the world's first successful airplane and make the first controlled, powered, and sustained heavier-than-air human flight in 1903. A milestone in aviation history.

BEYOND THE CRADLE

In a simple log house about 200 km (120 m) southwest of Moscow, Konstantin Tsiolkovsky further theorizes about airships, airplanes, hovercrafts, and rockets for interplanetary travel. In 1903 he publishes an article

fig. 64

Investigation of Outer Space Rocket Devices, in which he proves for the first time that a rocket could perform space flight. In this article, and its subsequent sequels in 1911 and 1914, he develops some ideas of missiles and the use of liquid rocket engines. The latter publication of this article creates ripples in the scientific world, and Tsiolkovsky finds many friends and followers among his fellow scientists.

Ironically, the father of rocket science never actually builds a rocket; apparently he does not expect many of his theories to ever be implemented. For Tsiolkovsky his theory of rocket science is only a supplement to philosophical research on the subject. His oft-quoted justification for space exploration in 1911 states: "The Earth is man's cradle, but one cannot live in the cradle for ever."

FRENCH PIONEER

fig. 65

The pioneering French aircraft designer, Robert Esnault-Pelterie also becomes interested in theoretical spaceflight and unaware of Tsiolkovsky's writings, produces a paper in 1913 that presents a rocket equation and calculates the energy required to reach the Moon and nearby planets.

MOON MAKER

In 1915, two Americans: physicist and inventor, Robert Wood and Arthur Train, a lawyer and writer of thrillers, co-author the science fiction novel, *The Man Who Rocked the Earth.* The duo publish a sequel, *The Moon Maker,* the following year. The sequel provides a unique and uncannily accurate depiction of interplanetary space travel with an atomic-powered spaceship.

fig. 66

JUNEBUG

In the same year, German writer Gerdt von Bassewitz publishes *Peterchens Mondfahrt (Little Peter's Journey to the Moon)*, an illustrated fairy-tale about two children who journey to the Moon. A Junebug finds the two children and they accompany him on a fantastical journey to the Moon to recover his missing leg.

fig. 67

SKY KNIGHTS

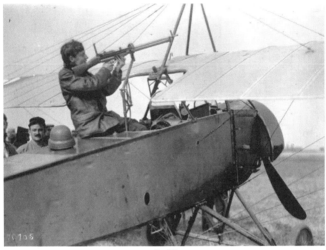

fig. 68

Airplanes are increasingly required for military use during the First World War (1914–1918). It is the first time that aircrafts are deployed on such a large scale. Fighter pilots are portrayed as modern knights, and many airmen become popular heroes.

LUNAR ORBIT
RENDEZVOUS

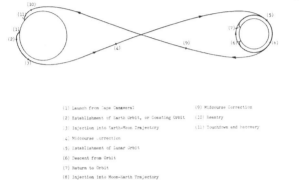

(1) Launch from Cape Canaveral

(2) Establishment of Earth Orbit, or Coasting Orbit

(3) Injection into Earth-Moon Trajectory

(4) Midcourse Correction

(5) Establishment of Lunar Orbit

(6) Descent from Orbit

(7) Return to Orbit

(8) Injection into Moon-Earth Trajectory

(9) Midcourse Correction

(10) Reentry

(11) Touchdown and Recovery

Figure 2.- Mission profile for lunar orbit rendezvous mission.

fig.69

Then in 1919, the theoretical basis for future Moon landings is set by a visionary, 22-year-old Ukrainian engineer and mathematician, Yuri Kondratyuk. In his unpublished work, *For Those, Who Shall Build*, the young theoretician developed the first known Lunar Orbit Rendezvous (LOR), a key concept for landing and return spaceflight from the Earth to the Moon. When the famous American astronaut, Neil Armstrong visited the Soviet Union after his historic flight to the Moon, he collected a handful of soil from outside Kondratyuk's house in Novosibirsk to acknowledge the latter's significant contribution to spaceflight. A crater on the Moon, as well as the trajectory a spacecraft makes from Earth's orbit to the Moon's orbit, are also named in honor of Kondratyuk.

EXTREME ALTITUDES

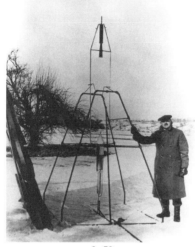

fig. 70

In the same year, the American theorist and engineer, Robert Goddard publishes his monograph, *A Method of Reaching Extreme Altitudes*, which is considered to be one of the classic texts of twentieth century rocket science. Five years earlier, in 1914, Goddard, who is known as the man who ushered in the Space Age, had already patented a multi-stage rocket and a liquid-fuel rocket. In 1920 Goddard writes an article for the journal, *Popular Science* describing the possibility of hitting the Moon with a rocket carrying enough flash powder to create a flash visible from the Earth.

Goddard successfully launches the first liquid-fueled rocket in 1926, thereby anticipating many

74

of the developments that are to make space travel possible. Goddard and his team launch a total of 24 rockets between 1926 and 1941, achieving altitudes as high as 2.6 km (1.6 m) and speeds as high as 885 km/h (550 mph).

WAYS TO SPACEFLIGHT

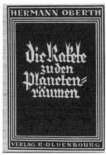

fig. 71

Another founding father of rocket science and astronautics, the German physicist and engineer, Hermann Oberth, has his proposed doctoral dissertation on rocket science rejected in 1922 as being too "utopian". Oberth, who memorized Jules Verne's *From the Earth to the Moon and Around the Moon* by heart at the age of 11 and built his first model rocket as a 14-year-old school pupil, then self-publishes his work *By Rocket into Planetary Space (Die Rakete zu den Planetenräumen)*. By 1929, Oberth has expanded this work in a far more comprehensive book entitled, *Ways to Spaceflight.*

75

ADVANCE INTO SPACE

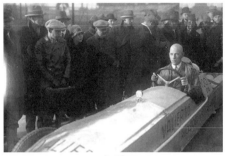

fig. 72

Max Valier, the Austrian freelance science journalist, and trained mechanic, is enthusiastic about Oberth's groundbreaking book and is inspired to write a similar work to explain Oberth's ideas in straightforward terms that could be understood by the common public. With Oberth's assistance, Valier publishes his seminal book *Der Vorstoß in den Weltenraum (The Advance into Space)* the following year. The book is an outstanding success, selling six editions until 1930.

Valier becomes one of the most notable space travel enthusiasts and rocket science pioneers in Europe. His widely distributed writings and spacecraft designs prove highly influential on scientific and science fiction writers and influence the public perception of spacecrafts. During 1928 and 1929, Valier works on a number of rocket-powered cars and aircrafts with Fritz von Opel. In 1930, Valier performed the first test drive of a rocket car with liquid propulsion, Valier was

killed less than a month later when an alcohol-fuelled rocket exploded on his test bench in Berlin.

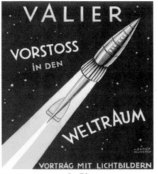

fig. 73

SICILLIAN LETTERS

German writer Ernst Jünger writes his *Sicillian Letters to the Man on the Moon* in 1930. A declaration of a critical advance from the optics of distance that shaped his writings on war toward what he calls a "higher trigonometry." He opens with an engaging remembrance of childhood when moonlight held him in terror, in that he feared its magnetic power would draw him into space. To him the lunar landscape provides work for astronomical topography but also for magical trigonometry, and so the Moon is simultaneously a province of science and spirits.

SHOT INTO INFINITY

fig. 74

Between 1925 and 1928, the German science journal-
ist and popular science fiction author, Otto Willi Gail,
writes novels and non-fiction books for young adults
that accurately mirror many of the space travel con-
cepts discussed by pre-war experts in Europe. Gail's
novels *Der Schuß ins All* (1925) *(The Shot into Infin-
ity)*, *Der Stein vom Mond* (1926) *(The Stone From the
Moon)*, *Hans Hardts Mondfahrt* (1928) *(By Rocket to
the Moon)* are convincing thanks to their specialized
knowledge and depth of detail. Gail's novels are trans-
lated into English and influence early American uto-
pian literature.

fig. 75

WOMAN
IN THE MOON

In 1929, another ingenious collaboration of the arts and the sciences of the time was the first realistic depic-

fig. 76

tion of spaceflight in cinematic history and the premier of the science fiction, silent film genre, *Woman in the Moon* (1929). Directed and produced by Fritz Lang, the great film pioneer and director of the futuristic-dystopian *Metropolis* (1927), the film becomes a great success and is also released in the United States under the title, *By Rocket to the Moon* and in the UK under the title, *Woman in the Moon.*

Hermann Oberth along with Willy Ley, another space travel advocate and science writer, work as scientific consultants on Lang's film that presents the basics of rocket travel—including the use of multi-stage rockets—to a mass audience. One of Oberth's main assignments is to build and launch a rocket as a publicity event just prior to the film's premiere. Unfortunately this project never materializes. However, Oberth and Ley do design a model of the main rocket portrayed

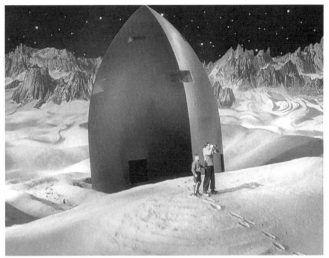

fig. 77

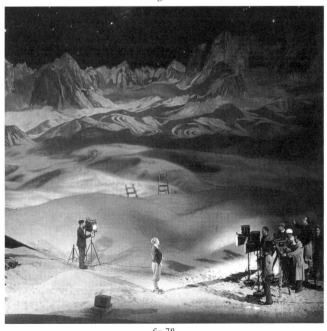

fig. 78

in the film. As Fritz Lang later recalled, the work they had done was "so accurate that, in 1937, the Gestapo confiscated not only all models of the spaceship, but also all foreign prints of the picture."

The movie also contributed to future space flight in a very practical way: Fritz Lang invented the countdown for dramaturgic reasons: "When I shot the take-off of the rocket, I said, if I count one, two, three, four, ten, fifty, hundred, the audience will not know when it launches. However if I count backwards: Ten, nine, eight, seven, six, five, four, three, two, one, ZERO! – they understand it."

 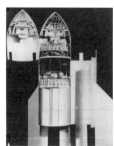

fig. 79–81

SOCIETY FOR SPACE TRAVEL

fig. 82

Due to influences from the likes of Oberth, Ley, Valier, and other popular scientific writers, Germany actually witnesses a short-lived rocket science craze in the late 1920s and early 1930s. Following the collaboration on Lang's film, the *Verein für Raumschiffahrt (Society for Space Travel)* is founded as an amateur rocket science association with its own journal entitled, *Die Rakete (The Rocket)*. In 1930, the society—known as VfR—contacts the German army and receives permission from the municipality to use an abandoned ammunition dump in Berlin, where they test fire increasingly powerful rockets of their own design for the following three years.

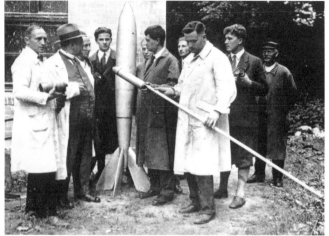

fig. 83

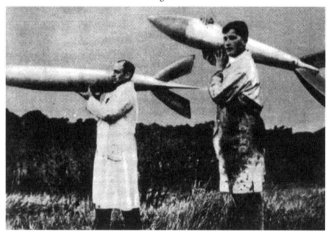

fig. 84

GREAT DEPRESSION

fig. 85

The enthusiasm for future possibilities of space travel and for the potential for new "weapons of wonder" is not only confined to the German public, but spreads internationally. Despite the many successes, the craze for rockets cannot be sustained and the public loses interest amidst the economic turmoil across the globe. Against the backdrop of the infamous stock market crash of 1929—signaling the beginning of the decade-long Great Depression that adversely affects all Western industrialized countries—the originally serious and scientific approach to Moon travel fades away as the 1930s approach. From then on, opportunities for finding financial support prove impossible.

BUCK ROGERS AND FLASH GORDON

fig. 86

Despite the enormous value that all of the scientific and technological achievements of the 1920s have in popularizing the ideas of rocket science and space exploration, the following decade experiences a set back for the acceptance and recognition of astronautics in the public's perception. With comic strips and motion picture serials, *Buck Rogers* and *Flash Gordon* become widely popular and space travel and Moon flight once again enter the realm of pure fantasy.

ASTOUNDING STORIES

The authentic spacecrafts of the 1920s degenerates into pulp fantasy in the 1930s and its *Verein für Raumschiffahrt* pioneers meet very different fates. Spaceflight's key innovator, Oberth moves directly from

fig. 87

ridicule to obsolescence as a high school teacher of physics and math, and finally into pensioned obscurity. The rocket science enthusiast, Valier loses his life in an explosion whilst test-driving one of his rocket cars in Berlin. Ley flees to the United States in order to escape Hitler's grip on power and continues to promote spaceflight across the Atlantic. He manages to promote space flight by supervising operations of two rocket planes transporting mail and by publishing scientific articles in American science fiction magazines. His first article "The Dawn of the Conquest of Space" is published in the March 1937 issue of *Astounding Stories.*

NAZI
ROCKET SCIENCE

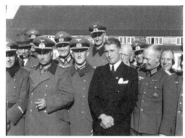

fig. 88

Yet, the youngest member of the no-longer existent *Verein für Raumschiffahrt* and future space architect Wernher von Braun, continues to dream of devoting his life to reaching the Moon and becomes the leading figure in the development of rocket technology in Germany during World War II and, subsequently, in the United States. With the Nazis in government in Germany, rocket science almost immediately becomes part of the national agenda. Von Braun and his team of engineers and military personnel are allocated $ 100 million by the German army to develop missiles and rockets at Peenemunde on the Baltic Sea.

Dubious mastermind, von Braun exploits the military and forced labor prisoners to further his covert vision of traveling to the Moon. In the midst of the Second World War, von Braun—only 30 years old at the time-launches the Aggregat 4 rocket in 1942. This marks the development of a rocket that breaches the boundaries of space and time for the first time in

history. The long-range ballistic rocket later renamed V-2-Vergeltungswaffe "vengeance weapon" is on the path of becoming and creating a space ship.

VENGEANCE WEAPON

fig. 89 fig. 90

While Willy Ley publishes his book *Rockets—The Future of Travel Beyond the Stratosphere* in the United States, which describes early rockets and more futuristic projects to reach the Moon using a 3-stage rocket "as high as ⅓ of the Empire State Building," the V-2s are launched as combat-ballistic missiles by the German army against Allied targets during the War, mostly in London, and later in Antwerp and Liège in 1944. The attacks resulted in the deaths of an estimated 9,000 civilians and military personnel, while 12,000 forced laborers and concentration camp prisoners lost their lives producing the weapons.

JUMP-START

fig. 91

Towards the end of the Second World War, the German forces have several advanced types of aircraft, guided missiles, and unusual aeronautical projects in development. In the aftermath of the Second World War the American, Soviet, and British governments all gain access to the V-2's technical designs, as well as to the specific German scientists responsible for creating the rockets. Wernher von Braun and his Peenemunde planning staff go on to work for the United States after the war and jump-start the American space program. It is this rocket team that ultimately manages to get man on the Moon.

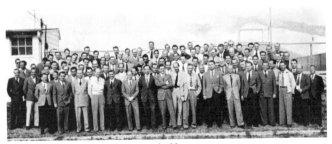

fig. 92

SPACE MONKEY

fig. 93

Before humans ventured into space, several animals unwittingly lose their lives in the name of progress, including numerous primates in the late 1940s. Albert, a Rhesus monkey, is the first of many primate astronauts to be sent into space on a modified V-2 rocket in 1948. Unfortunately, Albert dies of suffocation en route as did most of his successors. In 1949, Albert is followed by Albert II who survives the V-2 flight, but dies on impact after a parachute failure. Overall 32 monkeys fly in the space program.

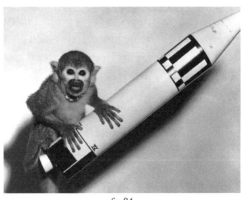

fig. 94

SPACE ART

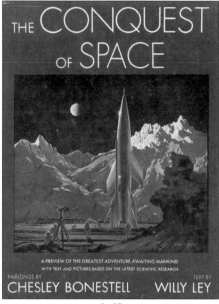

fig. 95

In 1946, *Life* magazine publishes twelve paintings of a hypothetical flight to the Moon by Chesley Bonestell, a trained architect who spent nearly three decades helping to design landmark buildings across the United States prior to becoming the "Father of Modern Space Art". But it is the speculative science book *The Conquest of Space,* published in 1949—with texts by rocket expert, Willy Ley—that is primarily responsible for bringing Bonestell's planetary landscapes to a new generation of space-travel enthusiasts. The book has four print runs within the first three months of publication.

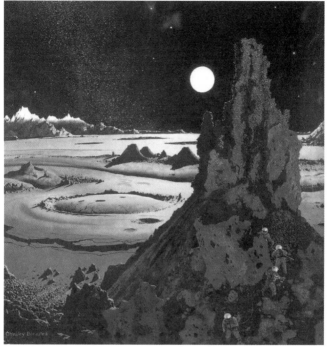

fig. 96

Bonestell's visionary illustrations galvanize readers. The depiction of the Moon and other planets do not bear the stigma of being a mere artist's impression. Neither sensationalism nor exaggeration characterize his paintings, but rather a matter-of-fact representation of places that exist in reality. Bonestell's images are like postcards from the future.

COLLIER'S

Repeating Verne's accomplishment of demonstrating the achievement of spaceflight by means of contemporary technology and materials, Bonestell continues to

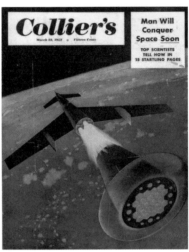

fig. 97

collaborate with space personalities of the time, such as Willy Ley and Wernher von Braun. In 1952 the artist illustrates a series of magazine articles entitled "Man Will Conquer Space Soon!" written by von Braun about the future of space travel for *Collier's* magazine.

The *Collier's* series has an enormous impact on the public imagination and feeds their enthusiasm for spaceflight. Continuing the history of the relationship between astronautics and the arts, the prime instigators of the golden age of space travel are a rocket sci-

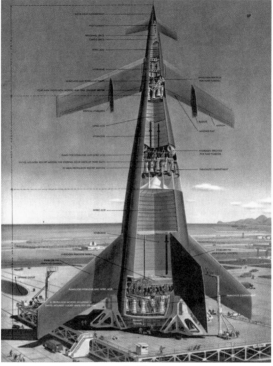

fig. 98

entist and an artist. The duo, von Braun and Bonestell are responsible for the enormous public enthusiasm for spaceflight. Von Braun realizes early on that in a democracy-different to a dictatorship- the general public must be won over to get the government to invest in the development of space flight. Public relations therefore becomes an important line of action for the rocket-scientist.

GOLDEN SPACE AGE

fig. 99

By the early 1950s space travel is part of everyday popular culture. Interestingly, the golden age of space travel arrives before space travel actually becomes a reality. During the decades following the Second World War, fueled largely by post-war optimism combined with the

fig. 100

belief in technology and engineering, the possibility of spaceflight takes a firm hold on the public's imagination.

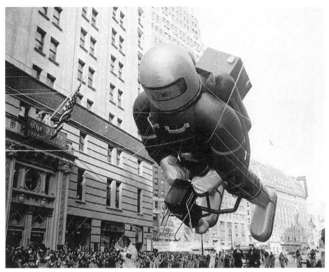

fig. 101

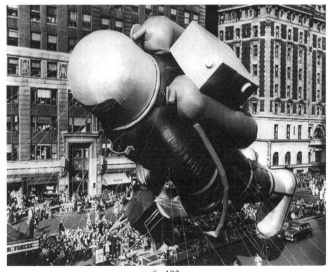

fig. 102

SPACE HAPPY

References to rockets and space travel are ubiquitous, from television and movies, to literature and comic books, toys and games, to bubblegum and breakfast cereal. More non-fiction books about rockets and

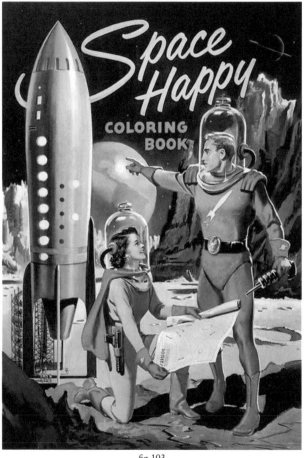

fig. 103

space travel are published for young readers than at any other time before or since.

fig. 104

fig. 105

PRELUDE TO SPACE

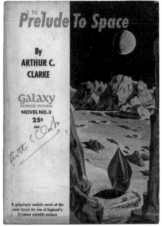
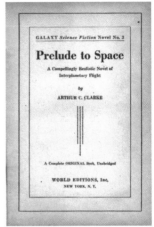

fig. 106

British scientist and science fiction writer, Arthur C. Clarke's 1951 novel, *Prelude to Space* recounts the fictional events anticipating the launch of the world's first spacecraft capable of reaching the Moon in 1978. The novel follows the idea that space travel is a realistic endeavor for the general public. In 1954 Clarke even speculates about the establishment of a permanent and, eventually, self-supporting lunar settlement in his book, *The Exploration of the Moon*.

SPACE PATROL

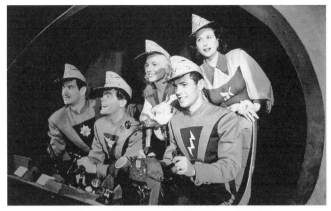

fig. 107

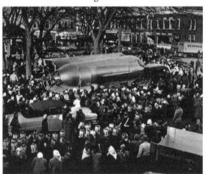

fig. 108

The science fiction adventure series, *Space Patrol* begins broadcasting in 1950 and becomes an immediate sensation. The arrival of a full-size Space Patrol "rocket-ship" in town is a huge media event at the time. Simultaneously, *Tom Corbett—Space Cadet* (another television space series) airs for the first time. Willy Ley is employed for his expert advice in the production.

DESTINATION MOON

Saturated with bone fide science and realistic cinematic images of technological possibilities, contemporary science fiction movies create even more positive images about the future of space travel. Exceptional

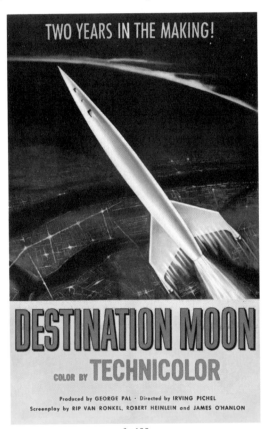

fig. 109

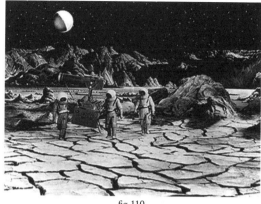

fig. 110

amongst this genre is George Pal's film, *Destination Moon* (1950), which depicts a journey to the Moon. The portrayal is true in almost every detail to the scientific projections of the time. Chesley Bonestell is responsible for the panoramic matte paintings of the moonscapes in the film.

fig. 111

EXPLORERS ON THE MOON

fig. 112

Belgian cartoonist, Georges "Hergé" Remi, illustrates space travel and lunar landscapes in *The Adventures of Tintin comic, Destination Moon* (1953) and *Explorers on the Moon* (1954). His drawings are based on Bonestell's illustrations of the Moon in the book *The Conquest of Space.*

fig. 113

DISNEY'S MOON

The most well known spin-off of *Collier's* articles is a series of programs broadcast as part of Walt Disney's *Disneyland* television show, which begins airing in 1954. An anthology of three short Disney films about the future of space exploration are produced, entitled *Man in Space, Man and the Moon,* and *Mars and Beyond,* with the expertise of Wernher von Braun, Heinz Haber, Ernst Stuhlinger, and Willy Ley.

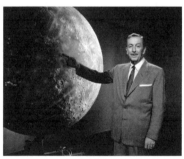

fig. 114

The shows outlined the history of rocket science and a von Braun-inspired, step-by-step program for space travel. The first show in 1955 is viewed by nearly 100 million people, or half of the population of the United States. Amongst the viewers is President Dwight D. Eisenhower who is so fascinated by the perspectives of outer space that he borrows a copy to show to officials at the Pentagon. Only four months later, Eisenhower announces that the United States will launch an artificial Earth satellite as part of the upcoming Geophysical Year 1957/58.

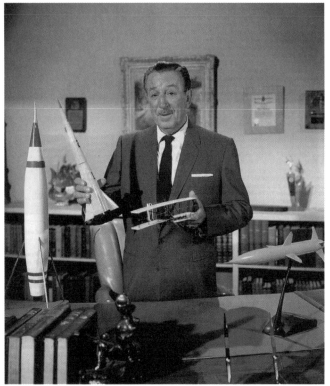

fig. 115

The ingenious mix of art, science, and entertainment serves as a prediction of the future of space travel and is instrumental in raising public awareness of the imminent reality of spaceflight. It also informed the Government—which has allocated many billions of dollars to a space program—that it has the enthusiastic support of its taxpayers.

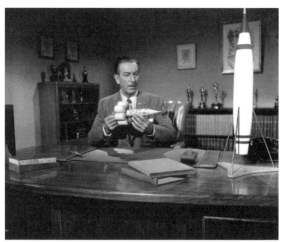

fig. 116

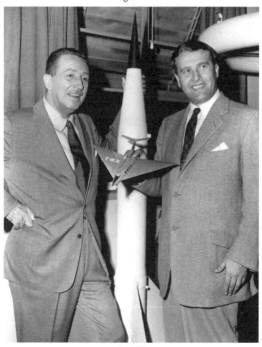

fig. 117

SPACE RACE

fig. 118

With the successful launch of the world's first artificial satellite, Sputnik 1, into an elliptical, low Earth orbit by the Soviet Union as part of the International Geophysical Year, the twentieth century Space Race is officially started in 1957. From thenceforth, the two Cold War rivals, the Soviet Union and the United States, battle for supremacy in spaceflight capability, ushering in a plethora of new political, military, technological, and scientific developments along the way.

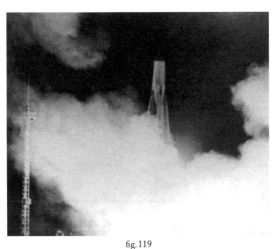

fig. 119

LAIKA

fig. 120

Less than a month after the launch of Sputnik 1, the USSR presents the world with its first astronaut heroine: Laika, a stray dog from the streets of Moscow, who becomes the first animal to orbit Earth on board Sputnik 2. Laika survives for approximately three days before she dies due to overheating in the cabin. The experiment aims to prove that a passenger could survive being launched into orbit and endure weightlessness unscathed, thus paving the way for human space travel.

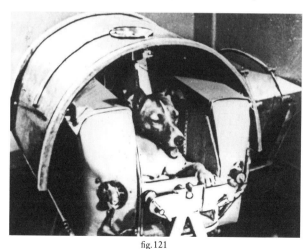

fig. 121

SPUTNIK CRISIS

fig. 122

After the Soviet launch of Sputnik, the attention of the United States turns towards its own fledgling space efforts. The "Sputnik crisis"—a term coined by Eisenhower to describe a period of public fear and uncertainty in the United States in the wake of the success of the Soviet Sputnik program, and a perceived technological gap between the two superpowers—urges immediate and swift action. In 1958, the American Government establishes the National Aeronautics and Space Administration (NASA), responsible for the nation's civilian space program, for aeronautics, and aerospace research.

LUNEX PROJECT

Concepts of establishing a human presence on the Moon develop to an ever-greater degree. The Lunex Project, conceptualized in 1958, for example, is a U.S.

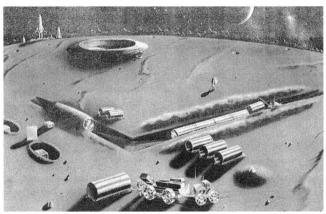

fig. 123

Air Force plant to construct an underground Air Force Base on the Moon. A year later, the U.S. Army's Ballistic Missile Agency even organizes a task force, involving von Braun, called Project Horizon to assess the feasibility of constructing a military base on the Moon.

BOMBS
ON THE MOON

AFSWC-TR 59-39

SWC
TR
59-39
Vol I

HEADQUARTERS

AIR FORCE SPECIAL WEAPONS CENTER

AIR RESEARCH AND DEVELOPMENT COMMAND

KIRTLAND AIR FORCE BASE, NEW MEXICO

CATALOGED BY DDC
AS AD NO.____

425380

A STUDY OF LUNAR RESEARCH FLIGHTS
Vol 1

by

L. Reiffel

ARMOUR RESEARCH FOUNDATION

of

Illinois Institute of Technology
19 June 1959

fig. 124

Moreover, the United States Air Force develops the top-secret plan, Project A119, also known as Study of Lunar Research Flights in 1958 with the aim of detonating a nuclear bomb on the Moon. There was a show of force and domestic morale boost in the United States after the Soviet Union—who was also working on a similar project—took an early lead in the Space Race. Interestingly, neither the Soviet, nor the U.S. project is carried out.

LUNAR HILTON

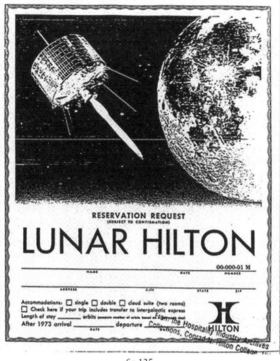

RESERVATION REQUEST
(SUBJECT TO CONFIRMATION)

LUNAR HILTON

00-000-01 M

fig.125

In 1958 even the Hilton Hotel chain plays with the idea of opening the first hotel on the moon: The Lunar Hilton Hotel. A 100-room hotel built below the surface. Guests would gather around a piano bar in an observation dome that allowed them to gaze back at Earth. The hotel group even prints promotional reservation cards for customers to reserve a hotel room on the Moon.

COMMITTEE ON PEACEFUL USES OF OUTER SPACE

fig. 126

Against the backdrop of the potential militarization of space, nations worldwide began discussing systems to ensure the peaceful exploration of outer space. Bilateral discussions between the United States and the Soviet Union in 1958 result in the presentation of issues to the United Nations for debate. A year later, the United Nations creates the Committee on Peaceful Uses of Outer Space (COPUOS), to review the scope of international cooperation in the peaceful exploration of outer space.

CELESTIAL CONTACT

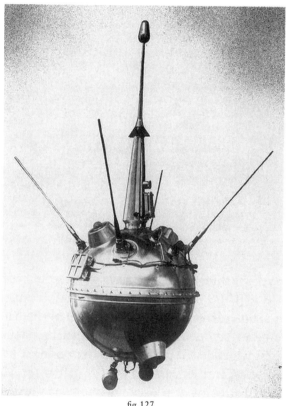

fig. 127

Luna 2, the second of the Soviet Union's Luna program of robotic spacecraft missions is launched to the Moon and successfully reaches the surface of the Moon in 1959. It is the first man-made object to land on another celestial body.

FAR SIDE OF THE MOON

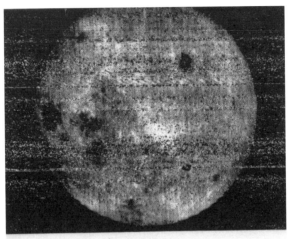

Фотография 1
fig. 128

Luna 3, the third space probe sent to the vicinity of the Moon in 1959, returns the first low-resolution—by later standards—images of the far side of the Moon. The never-before-seen views cause excitement and interest when distributed around the world. A provisional atlas, entitled *Atlas of the Far Side of the Moon*, is created after image processing improved the quality of the images.

12 TO THE MOON

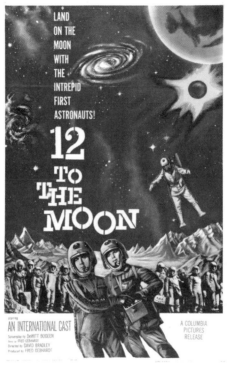

fig. 129

While David Bradley's science fiction film, *12 to the Moon* (1960), still fantastically portrays an international crew embarking on an expedition to the Moon in an uncommonly spacious rocket-ship, where they encounter hostile cat-like aliens, the real-world Space Race reaches an entirely new level during the 1960s.

COSMONAUT GAGARIN

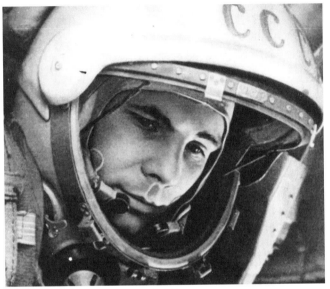

fig. 130

On April 12, 1961, the Soviet pilot and cosmonaut, Yuri Gagarin becomes the first human to orbit the Earth. The orbit lasts 108 minutes before Gagarin returns to Earth, ejecting from the capsule 7 km (4.35 mi) above ground and parachuting to Earth. This historic flight propels him into a global celebrity and Gagarin pays numerous visits to countries across the world over the next few years. He revels in the fame but is restricted from undertaking any further space-flights, as the Soviets do not want to lose their famous cosmonaut.

SPACE AGE COMMUNISM

With Gagarin's launch into orbit, the Soviet leadership announces the arrival of an epoch of historical equal importance to the Bolshevik Revolution. While

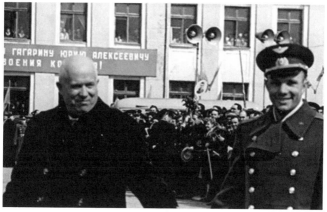

fig. 131

the events of 1917 marked the leap from a Tsarist autocracy to transitory socialism, the conquest of cosmic space, according to self-proclaimed "space-father," Premier Khrushchev, signaled the attainment of "Space-Age Communism".

The presentation of cosmonauts as exemplary Soviet subjects—whether in elaborate public demonstrations or in print, radio, television, or film—was a highly orchestrated activity on the domestic and international stage overseen by the upper echelons of the Communist Party.

FREEDOM 7

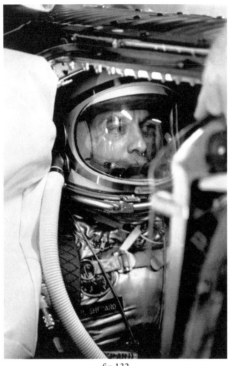

fig. 132

A month after Gagarin's orbit, he is followed by Alan Shepard who becomes the first American astronaut to travel into space. The launch of the *Freedom 7* mission is seen live on television by millions of viewers. Unlike Gagarin's orbital flight, Shepard however stays on a ballistic trajectory of a 15-minute suborbital flight.

WE CHOOSE TO GO TO THE MOON

When John F. Kennedy becomes president in 1961, the perception in America is that the United States is losing the Space Race against the Soviets. In an

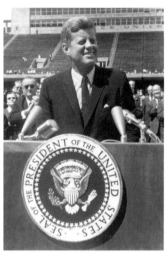

fig. 133

attempt to beat the Soviet accomplishment of launching the first human into space, Kennedy confidently proclaims for the first time before Congress, and then a year later in his legendary "We choose to go to the Moon" speech at Rice University in 1962, that the United States plans to transport an American citizen to the Moon before the end of the decade.

APOLLO

fig. 134

This assurance is based on pure speculation and a stunning absence of the required technologies, materials, or funding that would make such a mission even remotely possible. Nonetheless, NASA's Apollo program is developed the same year to achieve President Kennedy's national goal of manned space flight to the Moon.

The U.S. lunar space program is named after the Olympian deity, Apollo in classical Greek and Roman religion and mythology, who is known for his accurate aim at archery.

fig. 135

LUNAR MODULE

After a strenuous process, NASA announces in 1962 that the Grumman Aircraft Corporation has won the contract to build the Lunar Module (LM)—the space-

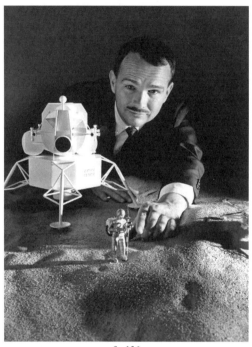

fig. 136

craft that would take astronauts to the Moon—for Project Apollo. This is the first, and will be the only, vehicle designed to take humans from the Earth to the Moon. The LM is a vehicle so radically new, so complex, and yet so delicate that there are simply no existing examples to help with its design.

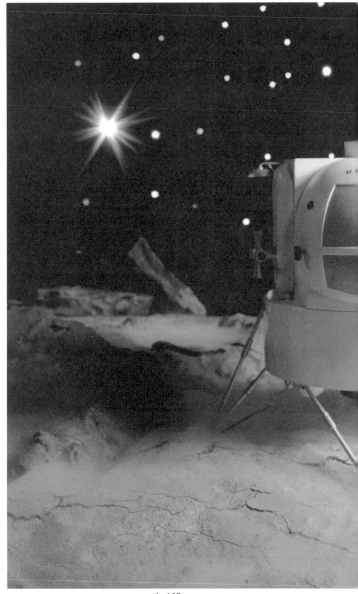

fig. 137
124

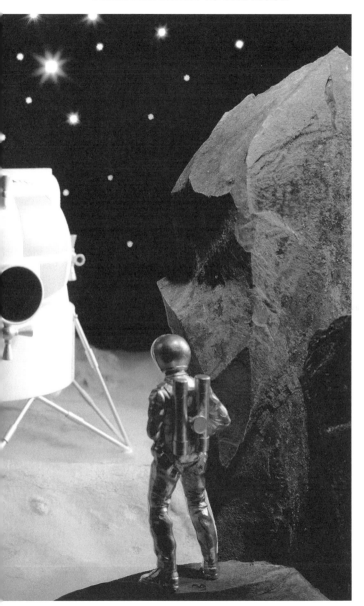

MYSTERY ON THE MOON

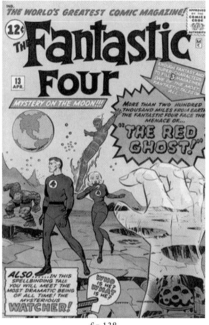

fig. 138

At the height of the Space Race, Marvel's superhero team, *Fantastic Four*, created by writer-editor, Stan Lee, and artist collaborator, Jack Kirby, recreate the first landing on the Moon and battle the communist supervillain, Ivan Kragoff (aka the Red Ghost) and his super apes. Before becoming the Red Ghost, Ivan was a Soviet scientist determined to beat the Americans to the Moon in order to be able to claim it for the Soviet Empire.

POWER

fig. 139

From the early 1960s, the NASA Art Program commissions an array of artistic works, such as Paul Calle's oil on panel painting, *Power* from 1963, which depicts the first seconds of the Saturn V Moon rocket lifting off. Each of the five large F-1 engines produces over 1.5 million pounds of thrust.

SPACEWALK

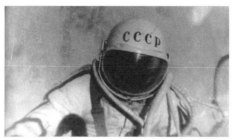

fig. 140

The first spacewalks and extra-vehicular activities in outer space are conducted in 1965. Soviet cosmonaut, Alexey Leonov, is the first outer space "walker". Three months later, the American astronaut, Ed White, also leaves the space capsule. The first spacewalk lasted 12 minutes, and the second 21 minutes.

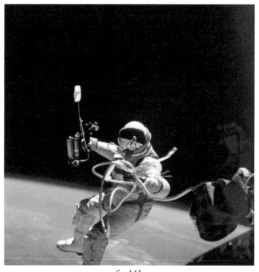

fig. 141

OUTER SPACE TREATY

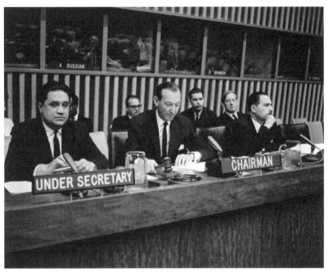

fig. 142

The development of space flight inevitably encompasses politics. The 1966, *Outer Space Treaty* forms the basis of international space law, which prohibits nuclear weapons or any weapon of mass destruction to orbit the Earth, or land on the Moon, or any other celestial bodies. At the same time, it prohibits nation states to claim the right of appropriation or sovereignty of the Moon. Furthermore, it limits the use of the Moon to solely peaceful purposes and prohibits any testing of weapons, or establishment of military bases etc. The Moon is declared to be the "common heritage of mankind".

OVERCOMING GRAVITY

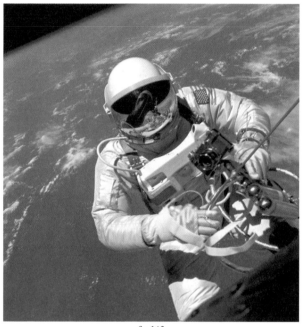

fig. 143

With space travel becoming a reality, humankind displays its ingenuity and ability to overcome the seemingly impossible; dreams were given wings strong enough to overcome even gravity. Nothing seemed too far-fetched and everything seemed within reach. The horizon seemed filled with endless possibilities despite growing unrest on planet Earth. The revolution of the 1960s has its origins in outer space.

SILVER FACTORY

fig. 144

Absolute belief in the promise of future technologies is the cornerstone of the new zeitgeist that subsequently infiltrates much of the design output of this era. The influence of space on the arts and culture is felt internationally. Even Andy Warhol's famous Factory is clad in tinfoil, silver paint, and fractured mirrors in order to resemble a spaceship.

BEYOND EUCLEDIAN SPACE

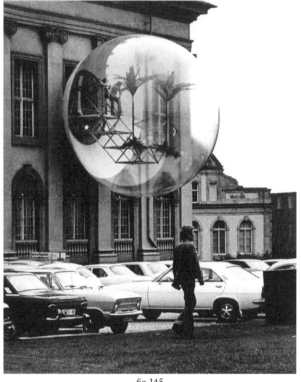

fig. 145

At this time, new eclectic working methods are established across all disciplines, in particular the arts and architecture, which transform and redefine existing spatial and intellectual structures. Against the backdrop of aviation in zero gravity, the traditionally static confines of architecture become obsolete.

The invention of the spacesuit, in particular, offers a supreme example of the newly discovered possibilities in the provision of basic, stand-alone shelter and

fig. 146

protection beyond Euclidean space; insubstantial and protective at the same time. It is no coincidence that singular, small, and apparently floating, pneumatic spaces arise as the signature of a novel, autonomous architecture.

133

HABITATION UNITS

Architectural inspiration during this period emerges from a similar reliance on non-existent technologies, as does the Apollo program at the time of its public announcement. A related tactic within the architectural profession is to adopt spin-off technologies that are actually realized for the lunar missions themselves.

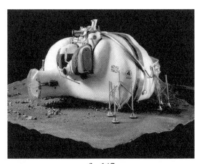

fig. 147

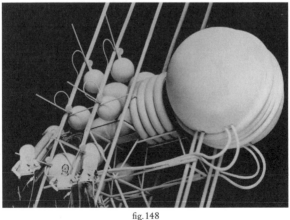

fig. 148

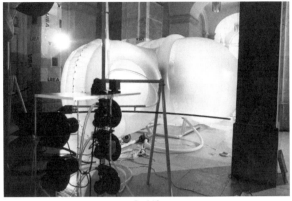

fig. 149

Such links can be seen in projects including Archigram's *Living Pod* (1966) and *Seaside Bubbles* (1966), or Coop Himmelblau's *Villa Rosa* (1968), all of which share a common exo-skeletal scaffolding structure combined with various forms of enclosed habitation units; all are strikingly similar to the designs of the Lunar Excursion Module (LEM), which had been in speculative development since as early as 1958.

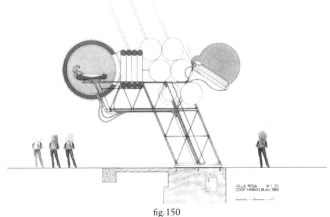

fig. 150

WALKING CITY

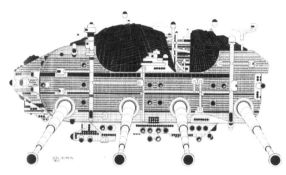

fig. 151

Only slightly less recognizable are architectural proposals derived from the possibilities that these new technologies suggest, such as Archigram's *Walking City* (1964). These projects recast technologies devel-

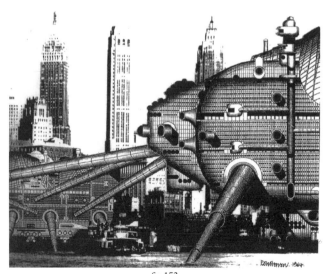

fig. 152

oped for actual mega-structures: the Apollo launch stack, crawler transporters, and umbilical tower are all mobile, reconfigurable, and massively-scaled contraptions designed to physically move Saturn 5 rockets into their required launch positions.

UPSCALE

Against the backdrop of this greatly revised concept of vastness and distance as prompted by the scale of the Apollo space program, new forms of linear utopia also emerge in the architectural domain, combined with the development of the car and its associated infrastructural needs. An example of this is Peter Eisenman and Michael Graves' Jersey Corridor Project from 1966.

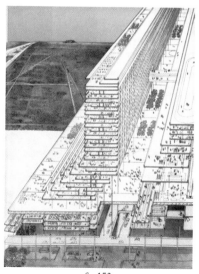

fig. 153

MOON IS THE OLDEST TV

fig. 154

At the forefront of a new generation of artists creating an aesthetic discourse from television and the moving image, is the Korean video artist, Nam June Paik, who completes his contemplative sculpture, *Moon Is the Oldest TV,* in 1965. Paik adds a magnet to the cathode tube of 11 television monitors, modifying the signal to produce an image on each screen representing the various phases of the lunar cycle.

fig. 155

MOON MAN

French illustrator and writer, Tomi Ungerer, publishes his classical children's book *Moon Man* in 1966, which tells the story of the earthly adventures of the curious man in the Moon and his safe return to his home

fig. 156

planet thanks to the help of a rocket scientist. Another popular "moon man" in children's literature of the time is Jerome Beatty's character, Matthew Looney, who lives with his sister, Maria, in the town of Crater Plato, on the Moon. A recurring theme in the books is Matthew's desire to know more about outer space, especially the Earth. At the beginning of the series, he stands on the Moon and looks up at Earth and wonders if it is inhabited by anyone.

fig. 157

SOFT LANDING

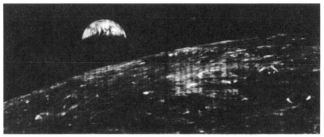

fig. 158

In the same year, the Soviets achieve the first soft landing of an unmanned spacecraft on the Moon (384,400 km from Earth). In 1966, Luna 9 is the first spacecraft to transmit photographic data to Earth from the surface of another planetary body. Shortly thereafter, the U.S. *Lunar Orbiter 1,* intended to help select Apollo landing sites on the Moon's surface, takes the first images showing the Earth in it's entirety.

fig. 159

WHOLE EARTH

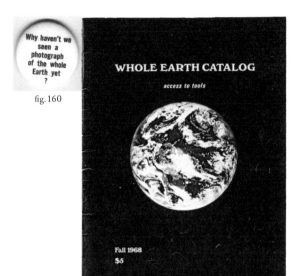

fig. 160

fig. 161

The Space Race is felt in all spheres of life and across all disciplines, and paves the way for new ways of understanding and experiencing time and space. In 1966, the American writer and counterculture activist, Stewart Brand, initiates a public campaign to have NASA release the image of the entire Earth as seen from space. Brand regards the image as a powerful symbol, evoking a sense of shared destiny and responsibility for all mankind. The photograph *Whole Earth* later adorned the first edition of Stewart Brand's legendary *Whole Earth Catalog* in autumn 1968.

TERRA NULIUS

Treaty on Principles Governing the Activities of States in the Exploration and Use of Outer Space, Including the Moon and Other Celestial Bodies (January 27, 1967)

Web Version: http://www.state.gov/t/ac/trt/5181.htm

The States Parties to this Treaty,

Inspired by the great prospects opening up before mankind as a result of mans entry into outer space,

Recognizing the common interest of all mankind in the progress of the exploration and use of outer space for peaceful purposes,

Believing that the exploration and use of outer space should be carried on for the benefit of all peoples irrespective of the degree of their economic or scientific development,

Desiring to contribute to broad international co-operation in the scientific as well as the legal aspects of the exploration and use of outer space for peaceful purposes,

Believing that such co-operation will contribute to the development of mutual understanding and to the strengthening of friendly relations between States and peoples,

Recalling resolution 1962 (XVIII), entitled "Declaration of Legal Principles Governing the Activities of States in the Exploration and Use of Outer Space," which was adopted unanimously by the United Nations General Assembly on 13 December 1963,

Recalling resolution 1884 (XVIII), calling upon States to refrain from placing in orbit around the Earth any objects carrying nuclear weapons or any other kinds of weapons of mass destruction or from installing such weapons on celestial bodies, which was adopted unanimously by the United Nations General Assembly on 17 October 1963,

Taking account of United Nations General Assembly resolution 110 (II) of 3 November 1947, which condemned propaganda designed or likely to provoke or encourage any threat to the peace, breach of the peace or act of aggression, and considering that the aforementioned resolution is applicable to outer space,

Convinced that a Treaty on Principles Governing the Activities of States in the Exploration and Use of Outer Space, including the Moon and Other Celestial Bodies, will further the Purposes and Principles of the Charter of the United Nations,

Have agreed on the following:

Article I

fig. 162

In 1967, the United States, the United Kingdom, and the Soviet Union sign the *Outer Space Treaty,* formally the *Treaty on Principles Governing the Activities of States in the Exploration and Use of Outer Space, including the Moon and Other Celestial Bodies.* The treaty declares the Moon to be *terra nullius,* a world belonging to no one. Around 100 nations still adhere to this agreement today.

CABIN FIRE

fig. 163

Apollo 1 is the first manned mission of the U.S manned lunar landing program. The planned low Earth orbital test of Command/Service Module never makes its target launch in 1967, because a cabin fire during a launch rehearsal test at Cape Canaveral kills all three crew members—Guss Grissom, Edward White II, and Roger B. Chaffee—and destroys the Command Module.

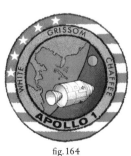

fig. 164

FRED FREEMAN

SATURN BLOCKHOUSE

fig. 165

As participants in NASA's art program, selected art-ists continue to gain unlimited access to space facilities during missions. In *Saturn Blockhouse* American art-ist, Fred Freeman depicts interior views of the NASA headquarters using acrylic on canvas. In the left hand corner of one of his paintings, Freeman's coffee cup rests on the console.

APOLLO 8

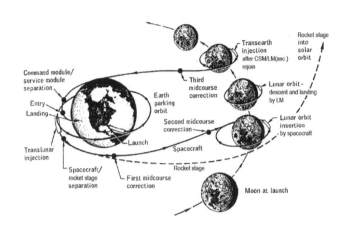

fig. 166

Launched in December 1968, Apollo 8 becomes the first manned spacecraft to leave Earth's orbit, reach the Moon's orbit after three days journey, and return safely to Earth. The spaceship orbited the Moon 10 times over the course of 20 hours, during which time the crew made a Christmas Eve television broadcast in which they read the first 10 verses from the *Book of Genesis*. At the time, the broadcast was the most watched television program ever.

FIRST MOON FLIGHTS CLUB

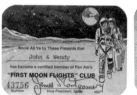

fig. 167

While the Apollo 8 mission orbited the Moon on Christmas 1968, Pan Am Airlines announces plans for commercial flights to the Moon. The First Moon Flights Club is created attracting more then 93,000 members over the next two decades, each convinced they would soon be following the astronauts into space. President Ronald Reagan is one of the first people to reserve a seat. New members receive a glossy membership card and a letter that helpfully explained what to expect next. "Starting date of service is not yet known" it warns Moon flight hopefuls, but asks for patience while the "essentials are worked out".

EARTHRISE

One image, in particular, of the Earth from space, known as *Earthrise*, taken by astronaut, William Anders in 1968 during the Apollo 8 mission, creates an overview of humankind's achievements and contributions, and prompts profound speculation on the future of our species. This photograph taken from the first manned voyage to orbit the Moon is considered to be the most influential environmental photograph ever taken.

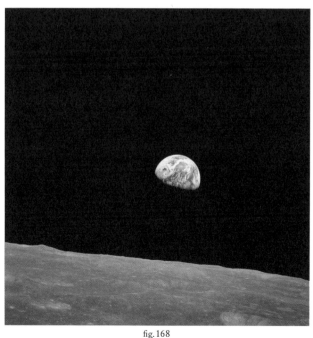

fig. 168

SPACESHIP EARTH

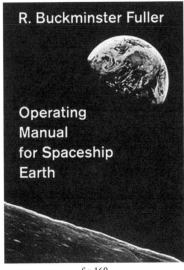

fig. 169

The *Earthrise* photograph also became the icon of American architect, system theorist, and futurist maverick, R. Buckminster "Bucky" Fuller's concept of *Spaceship Earth*, a call for international collaboration on issues of global importance. Published the same year and available via Brand's *Whole Earth Catalog*, Buckminster Fuller's *Operating Manual for Spaceship Earth*, compares the planet to a spaceship flying through space: a spaceship with a finite amount of resources that cannot be replenished.

SPACE ODYSSEY

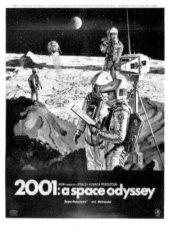

fig. 170

At the same time, American filmmaker, Stanley Kubrick uncannily anticipates the iconographic power of manned space flight with his enigmatic science fiction masterpiece, *2001: A Space Odyssey* (1968). Kubrick's cinematic imagination even predates the famous live televised pictures of the Earth and the Moon from Apollo 8 that will shake the foundations of human culture, experience, and self-perception a few months later.

SPACE ODDITY

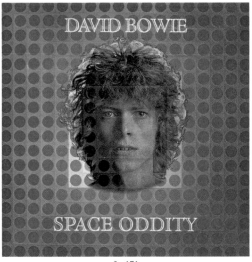

fig. 171

Based on Arthur C. Clarke's short-story, *The Sentinel* (1951), Kubrick's *2001* deals with the discovery of an artifact on the Moon left behind eons ago by ancient aliens. A black monolith, the appearance of which triggers evolutionary leaps for anyone that comes into contact with it: famously from ape to human, and then from human to "being of pure thought". Alluding to Kubrick's film *2001,* English pop icon, David Bowie, releases the renowned single, *Space Oddity*. The space ballade is about the launch of Major Tom, a fictional astronaut, who casually slips the bonds of the world to journey beyond the stars.

MOON ZERO TWO

Following shortly after 2001, is the science fiction film, *Moon Zero Two* (1969), directed by Roy Ward Baker, which is released and billed as a "space western". In the year 2021, the Moon is in the process of being colonized, and this new frontier attracts a diverse group of people to settlements, such as Moon City and Farside 5.

fig. 172

APOLLO 11

The same year, the dream is finally accomplished: Saturn V successfully launches Apollo 11 at the Kennedy Space Center on July 16, 1969. Saturn V remains the tallest, heaviest, and most powerful rocket ever to be launched: 110.6 m (363.9 ft.) high, 10.1 m (33 ft.) in diameter, and weighing an astounding 2,800,000 kg (6,2000,000 lbs.).

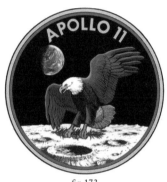

fig. 173

In addition to throngs of people crowding highways and beaches near the launch site, millions watch the event on television, with NASA Chief of Public Information, Jack King providing commentary. The Apollo's Saturn rocket is packed with enough fuel to fling 100-pound shrapnel three miles, and NASA cannot rule out the possibility that it might explode on takeoff. Therefore NASA positions its VIP spectators three and a half miles away from the launchpad.

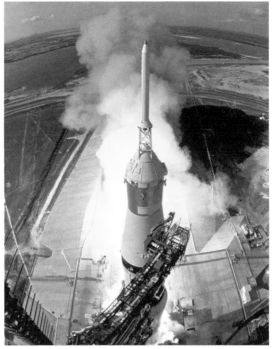

fig. 174

fig. 175

JACK PERLMUTTER

ROCKET ROLLOUT

fig. 176

At the time of the Apollo Moon-landing program, NASA artist-in-residence, Jack Perlmutter's oil-on-canvas painting, *Moon, Horizon, and Flowers (Rocket Rollout)* from 1969 abstractly reflects the bizarre mix of the most advanced technology with the subtropical natural landscape of Florida.

STONED MOON

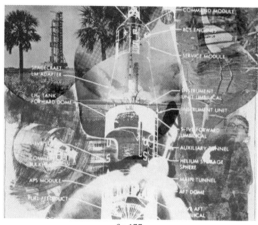

fig. 177

In 1969, American painter and graphic artist, Robert Rauschenberg—whose early works anticipated the pop art movement—is also invited to witness one of the most significant social events of the decade: the launch of Apollo 11, the shuttle that places man on the Moon. NASA provides Rauschenberg with detailed scientific maps, charts, and photographs of the launch, which forms the basis of the *Stoned Moon* series—comprising 33 lithographs. The series is a celebration of humankind's peaceful exploration of space as a "responsive, responsible collaboration between man and technology".

THE EAGLE HAS LANDED

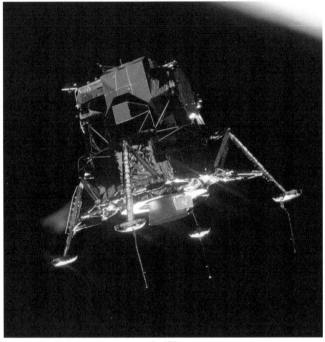

fig. 178

NASA astronauts of the Apollo 11 mission: Neil Armstrong, Buzz Aldrin, and Michael Collins are rocketed up to the Moon. While Collins remains in lunar orbit in the command spacecraft, Armstrong and Aldrin touchdown their Lunar Module on the Moon itself: finally—as the famous quote goes—"the Eagle has landed."

ONE SMALL STEP

Broadcast on live TV to a world-wide audience on July 20, 1969 Armstrong's famous words, "That's one small step for a man, one giant leap for mankind" and his photo of Buzz Aldrin on the Moon's surface

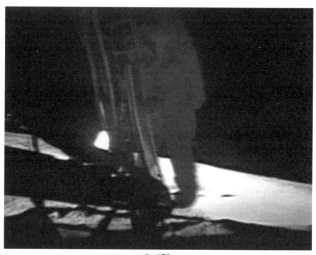

fig. 179

become instantaneous icons of U.S. space exploration. An estimated one-fifth of the world's population watches the live transmission of the Apollo 11 moonwalk on the Sea of Tranquility.

Neil Armstrong becomes the first person to step onto the lunar surface and spends about two and a half hours outside the spacecraft, whilst Buzz Aldrin spends slightly less time outside the space capsule.

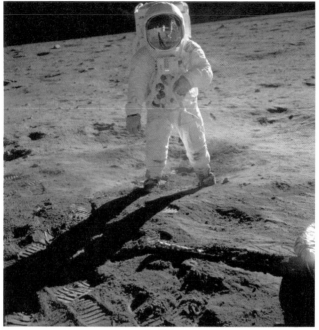

fig. 180

Armstrong walks a distance of 60 m (196 ft.) from the Lunar Module, while Aldrin tests methods for moving around, including taking two-foot-long jumps.

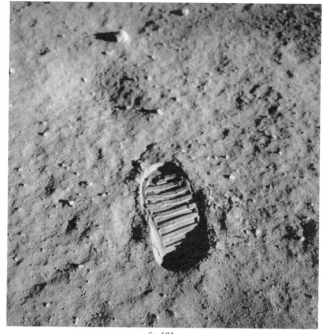

fig. 181

Standing on the Moon, Armstrong notices that he could blot out the entire planet Earth with his thumb. When being asked later whether that made him feel very big, he replies "No. It made me feel really, really small."

WE CAME
IN PEACE

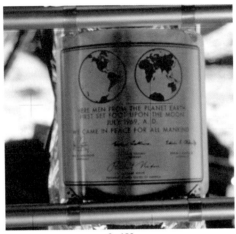

fig. 182

After their moonwalk, the astronauts leave behind various scientific instruments, an American flag, an Apollo 1 mission patch, and a plaque bearing two drawings of Earth (one of the Western and another of the Eastern Hemisphere), an inscription with signatures of the astronauts and President Nixon. The inscription reads: "Here men from the planet Earth first set foot upon the Moon, July 1969 A.D. We came in peace for all mankind."

They also leave behind a memorial bag containing a gold replica of an olive branch as a traditional symbol of peace and a silicon message disk. The disk carries, amongst other information, goodwill statements by Presidents Eisenhower, Kennedy, Johnson,

162

and Nixon, as well as messages from the leaders of 73 countries from around the world.

The Apollo 11 mission effectively ends the Space Race and fulfills the goal proposed by the late U.S. president, John F. Kennedy seven years earlier: to land a man on the Moon and return him safely to Earth before the end of the decade. Armstrong and Aldrin's moonwalk collapses the science fiction idea of colonizing other planets and demonstrates it as a scientific possibility.

Fascinatingly, the astronauts were paid a mere $ 8 per day, minus a deduction of the fee for their beds used on their historic Moon flights on Apollo. Buzz Aldrin allegedly still has a framed receipt on his wall stating: "From Houston to Cape Kennedy, Moon, Pacific Ocean. Amount claimed: $ 33.31."

fig. 183

163

GIANT LEAP TOUR

After being released from a 21-day quarantine, the crew members of Apollo 11 embark on another journey. The celebrations begin in New York City with a massive tickertape parade along the "Canyon of Heroes," Broadway and Park Avenue, to City Hall, and the United Nations headquarters. The U.S. victory lap continues westward with a huge party with President Nixon and many Hollywood stars at the Century Plaza Hotel in Los Angeles. President Richard Nixon authorizes the use of the presidential aircraft for a round-the-world astronaut Goodwill Tour coined "Project

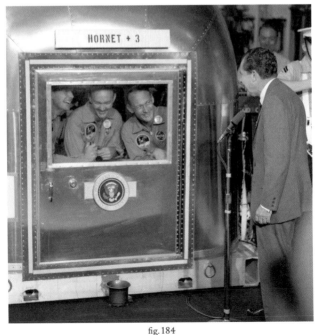

fig. 184

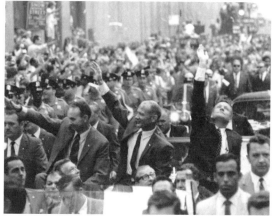

fig. 185

Giantstep" and dubbed the "Giant Leap Tour". In 45 days the astronauts and their wives fly to 24 cities worldwide mostly with overnight visits. At least 100 million people see the space crew and as many as 25,000 shake their hands, including Pope Paul VI.

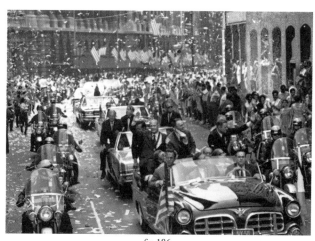

fig. 186

APOLLO AMERIKA

fig. 187

German artist Ferdinand Kriwet travels to the United States in 1969 to work on a audio book, film and publication entitled *Apollo Amerika*. He records the media reactions to the Apollo mission and focuses on how the media of telecommunication publishes the event across country. His sound piece was aired the same year for the first time and represents a milestone within acoustic art.

OCEAN OF STORMS

Only a week after the "Giant Leap Tour" comes to an end, Apollo 12 lands on the Moon in the Moon capsule, Ocean of Storms. Mission commander, Pete Conrad, and Lunar Module pilot, Alan Bean perform just over 31 hours of lunar surface activity while Command Module pilot, Richard Gordon, remains in lunar orbit. They carry the first color television camera to the lunar surface on an Apollo flight, but unfortunately transmission is lost after Bean accidentally destroys the camera by pointing it directly at the Sun.

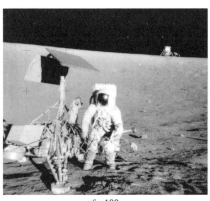

fig. 189

APOLLO ABORT

fig. 190

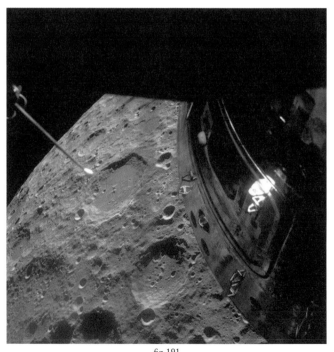

fig. 191

The Apollo 13 mission is the third mission intended to land on the Moon in the spring of 1970. An explosion on board, however, cripples the service module, containing the majority of the life support systems for the ship. This results in the abort of the lunar landing, and the very slim chance for the safe return of astronauts: Jim Lovell, Fred Haise, and Jack Swigert. The mission becomes famous thanks to the successful return of the three men, despite the remote chances of their survival.

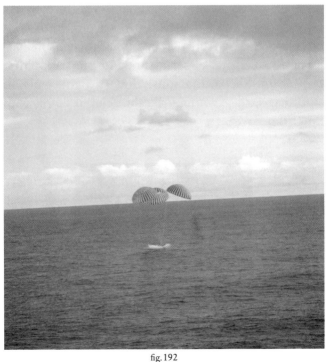

fig. 192

MOON GOLF

fig. 193

In 1971 the third manned mission to actually land on the Moon is Apollo 14. Commander Alan Shepard, one of the original Mercury Seven astronauts, and Lunar Module pilot, Edgar Mitchell, spend about 33 hours on the Moon, with about 9.5 hours of extra-vehicular-activity (EVA). Meanwhile Command Module pilot, Stuart Roosa, remains in lunar orbit performing scientific experiments and photographing the Moon. Shepard famously hits two golf balls on the lunar surface with a makeshift club brought with him from Earth.

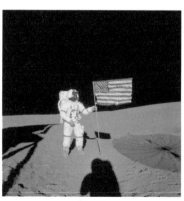

fig. 194

LUNAR CHEVY

fig. 195

fig. 196

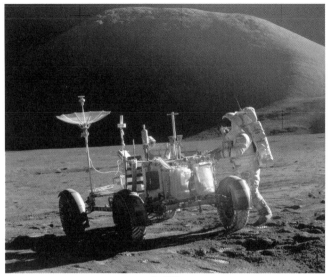

fig. 197

Later the same year, Apollo 15, lands as the fourth mission on the Moon. Commander David Scott and Lunar Module pilot, James Irwin spent three days on the Moon, 18.5 hours of which are spent outside the spacecraft. At the same time Command Module pilot, Alfred Worden orbits the Moon and studies the lunar surface and the lunar landscape in great detail.

Apollo 15 takes the ultimate symbol of home and the spirit of American mobility along with it: an automobile. The images taken of the Lunar Module, with a flag firmly planted and the Lunar Roving Vehicle parked outside, made the potential of colonizing space a future people could imagine. This was the lunar equivalent of the proud suburban homeowner, standing outside with the American flag adorning the porch with a "Chevy" parked in the driveway.

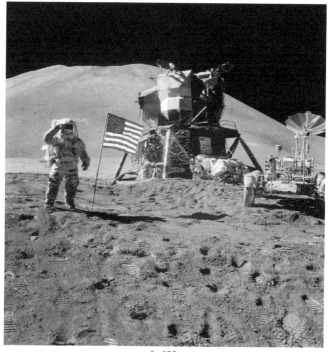

fig. 198

FALLEN ASTRONAUT

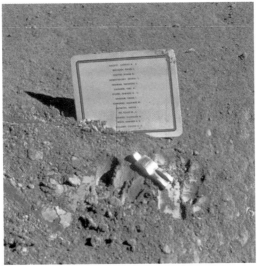

fig. 199

The crew of Apollo 15 also places a small 8.5 cm (ca. 3 in.) aluminum sculpture of an astronaut in a space-suit, called *Fallen Astronaut*, on the Moon. The sculpture commemorates the eight American astronauts and six Soviet cosmonauts who have died in the advancement of space exploration. Amongst them are the members of Apollo 1 crew, who both died in a tragic cabin fire during a pre-launch test in 1967, as well as Soviet spaceflight pioneers, Yuri Gagarin and Vladimir Komarov, both died before humankind set foot on the Moon.

LUNAR OLYMPICS

fig. 200

fig. 201

The following year, the penultimate Apollo 16 mission lands in the lunar highlands. While Command Module pilot, Ken Mattingly orbits above to perform observations while circling the Moon 64 times, Commander John Young and Lunar Module pilot, Charles Duke spend less than three days on the lunar surface, during which time three moonwalks are undertaken that total over 20 hours.

The pair drive the second Lunar Roving Vehicle, produced and used on the Moon, for approximately 26 km (16 mi). To the annoyance of Mission Control, Duke and Young also have a spontaneous session of

fig. 202

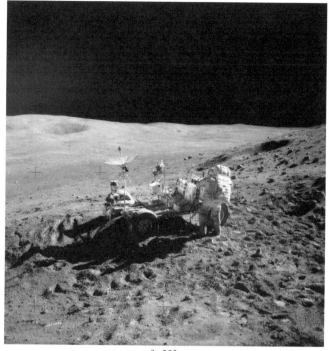

fig. 203

"Lunar Olympics," seeing how high they could jump with one-sixth of the Earth's gravity. With only one more flight in the Apollo program, Duke still holds the high-jump record on the Moon to this day!

MISSION COMPLETED

fig. 204

Last, but not least, the final mission of the United States' Apollo lunar-landing program brings humans successfully to the Moon for the sixth time on December 7, 1972. Apollo 17—with the three-member crew consisting of Commander Eugene Cernan, Command

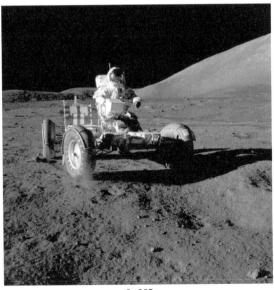

fig. 205

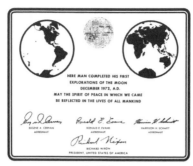

fig. 206

Module pilot, Ronald Evans, and Lunar Module pilot, Harrison Schmitt—breaks several records set by previous flights, including the longest manned lunar landing flight; the longest total lunar surface extra-vehicular-activities; the largest lunar sample return, and the longest time in lunar orbit to-date.

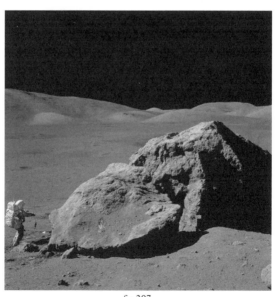

fig. 207

179

BLUE MARBLE

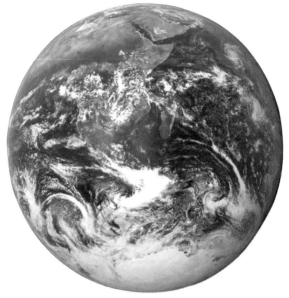

fig. 208

Furthermore, Apollo 17 not only remains the last manned Moon landing to-date, but also the last crewed flight beyond low Earth orbit. Not a single soul has travelled into outer space for over four decades! A snapshot taken by a crewmember of the Apollo 17 spacecraft becomes one of the most widely distributed photographic images in existence. The photograph, Blue Marble, depicts a view of the Earth traveling toward the Moon. Perhaps the unique opportunity to look at ourselves from beyond the confines of our Earth is in fact the most important reason for going to the Moon.

LUNAR ROCK

Over the course of three years, the Apollo program transports around 380 kg (838 lbs.) of lunar rocks and soil back to Earth. The rocks collected from the Moon

fig. 209

are extremely old compared to rocks found on Earth and range from about 3.2 billion to about 4.6 million years old. As such, they represent samples from a very early period in the development of our Solar System that are largely absent here on Earth.

Many expect that the basic Apollo program would conclude with Apollo 20, the 10th Moon landing mission, and then progress to advanced lunar missions in the Apollo follow-up program. This would include fortnightly lunar surface missions, in which scientist-astronauts would live in Apollo Lunar Module-derived "camper" landers and pilot lunar flying vehicles.

181

REALITY BITES

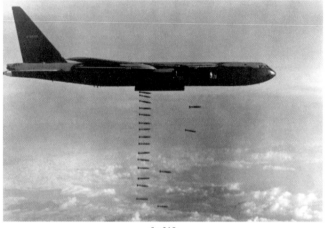

fig. 210

The moment that manned space flight becomes a reality, however, more pressing issues on Earth in the late 1960s and early 1970s (like the Vietnam War and the Cold War) bring an end to the frenzy of exploring space. With the goal of Moon landing being achieved, the vast sum of 25 billion dollars (equivalent to circa 100 billion dollars in 2015) invested on the space program suddenly seems no longer justifiable against the backdrop of the mounting cost of the Vietnam War, the Federal budget deficit, race riots, assassinations of civil rights leaders, and general political turmoil in the United States.

SOVIET MOON BASE DIVISION

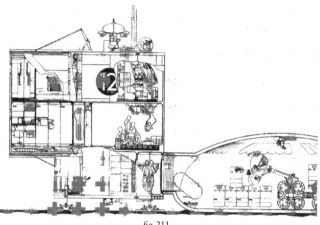

fig. 211

Despite the Soviet claim for robotic lunar exploration and the conventional wisdom that the Soviet lunar program was shut down after the American landing on the Moon, the Soviet Moon base division continues its work all the way up to the 1980s. At that point rocket scientists went so far as to build a life-size working model of a standardized living module to accommodate four people. They also conduct architectural experiments in order to perfect their projects. Even that model is later dismantled and no longer exists.

SPIN-OFFS

fig. 212

The Apollo program has been called the greatest technological achievement in human history. Yet, despite the paradoxical fact that there is no technology available for us to land on the Moon today, the technology existent at the time of the Apollo Moon landings is, by today's standards, no more powerful than a conventional pocket calculator. IBM described the 6 MB programs it specially developed to monitor the spacecrafts' environmental and the astronauts' biomedical data, as the most complex software ever written. Nonetheless, human and machine worked in ingenious unison to achieve something that—more than four decades or 40 years later—on, has yet to be surpassed. To guide astronauts across 384,000 km of space from the Earth to the Moon and return them safely, still remains an incredible feat.

 With the success of the Apollo program, NASA delivers great progress in the fields of rocket science and aeronautics, as well as in the fields of civil, mechanical,

and electrical engineering. Lesser-known accomplishments are some of the many spin-offs that came from the Apollo program-partnerships created between NASA and industry to commercialize the technologies developed for the historic missions to the Moon. All in all, since 1976, NASA's lunar program leads to over 1,300 technology spin-offs that are used in our daily lives.

Much of the knowledge gleaned from the Apollo program forms the basis of modern computing. Another example is the miniaturization of computer chips—an extension from many of the early manned spaceflight activities—which has revolutionized items we commonly use today: cell phones, smart phones, and tablet computers, to name only a few. Some of the most remarkable spin-offs, however, have been applied in the field of medicine, such as X-ray and ultra-sound imaging techniques, or radio imaging techniques.

HOW HIGH

Even the design and manufacturing of sports shoes benefits from the technology developed for the Apollo program. The Moon boot revolutionized athletic footwear, improving shock absorption, providing superior stability and motion control by adapting NASA space suit design technology and processes.

fig. 213

MOONWALKERS

Even more profound, however, is the effect the lunar program has on the astronauts who traveled to the Moon. Of over 400 people who have made the journey into space, only the 27 astronauts who have traveled to the Moon have ever left Earth's orbit and seen the Earth from the perspective of deep outer space.

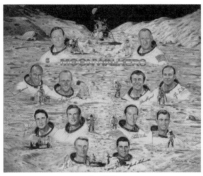

fig. 214

Between December 1968 and December 1972 these 27 astronauts traveled farther than anyone to-date. Of those 27 men, only 12 actually walked on the Moon. To this day, they remain the only humans who have ever walked on another celestial body.

RETURN TO EARTH

fig. 215

In the years after the last Moon landing a number of former Apollo crew members published their memoires and reflect upon the profound effect their unique journey has had on their lives—both for better and worse. Buzz Aldrin was the first cosmonaut to openly speak about his trials and tribulations, from crippling depression, to mental illness in the aftermath of the first Moon landing in his autobiography, *Return to Earth* published in 1973. Aldrin's book also revealed that NASA's PR department put constant pressure on the astronauts to set records in space.

Having accomplished what no person had ever accomplished before, these unique explorers are basi-

cally left to their own devices after the program ended. Having created these heroes and having used them to glorify their country, NASA pays them pittance and then leaves them to struggle without any support to deal with the consequences of their fame, and their physical and mental trials. Some cosmonauts seek solace in alcohol and live in obscurity, whilst others have epiph-

fig. 216

anies and find God, and others even try unsuccessfully to become politicians, or leave NASA and establish New Age cults. Alan Bean from Apollo 12 abandons flying to become an artist; unsurprisingly, he repeatedly paints only one single scene: the Moon.

The importance of the Apollo mission is largely neglected in the following decades. The feat of landing men on the Moon had been accomplished. The influence of the lunar journey can nonetheless be traced in very different forms in popular culture.

OF A FIRE
ON THE MOON

American writer Norman Mailer writes *Of a Fire on the Moon*, a work of nonfiction serialized in Life magazine from 1969 to 1970, and published in 1970 as

fig. 217

a book. It is an intensive documentary and reflection on the Apollo 11 Moon landing from Mailer's distinctive point of view. Mailer applies his Harvard aeronautical engineering qualifications to contemplate the radical new machines being born—the Moon rocket, the spacecraft, and the computers. As a writer, he meditates on the moral and philosophical relationship between the events of the modern human condition of the times, by observation of the psychology of astronauts, engineers, NASA bureaucrats—and himself.

MOON COLONIES

fig. 218

fig. 219

The Lathe of Heaven is a 1971 science fiction novel by American novelist, Ursula K. Le Guin, the plot of which revolves around a character whose dreams alter reality. In one of the alternate realities in the novel, lunar bases are established by 2002, only to be attacked by aliens from another planet, who turn out to be benign.

In a 1973 episode of the longest-running British science fiction television series, *Dr. Who*, the time-travelling protagonist is sentenced to life imprisonment in a penal colony on the Moon in the year 2540. The idea of a lunar colony also appears in American novelist, George R. R. Martin's 1974 science fiction story, *Dark, Dark Were the Tunnels*. Here, the story takes place on Earth, but which has been devastated by nuclear war 500 years earlier, and is being explored by descendants of a small remnant of humanity that managed to survive on a lunar colony.

DARK
SIDE

fig. 220

The British rock band, Pink Floyd, release their best-selling psychedelic album, *Dark Side of the Moon* in March 1973. The extremely successful album puzzles generations of teenagers over the album's hidden meanings. The lyrical themes focus on the darker aspects of human existence such as conflict, greed, the passage of time, death, and insanity. The latter theme was inspired, in part, by the band's principal composer and lyricist, Syd Barrett's deteriorating mental health.

TRAGEDY OF THE MOON

fig. 221

American author and professor of biochemistry, best known for his works of science fiction and for his popular science books, Isaac Asimov, publishes the novel *The Gods Themselves* in 1973. The third section of the novel takes place in a lunar settlement in the year 2100. Two years later, in 1975, Asimov publishes a collection of 17 non-fiction science essays, entitled *The Tragedy of the Moon*. The title of the book is also that of the first essay describing Asimov's speculations on what the effect on scientific and cultural advancement would have been had the Earth lacked a Moon.

LAGRANGIAN

The L5 Society is founded in 1975 by Carolyn and Keith Henson in order to promote the space colony ideas of American physicist and space activist, Gerald K. O'Neill. The name is derived from the L4 and L5 Lagrangian points in the Earth-Moon system, proposed as locations for the huge rotating space habitats that O'Neill envisioned. These points are of stable gravitational equilibrium located along the path of the Moon's orbit, 60 degrees ahead of it or behind it.

fig. 222

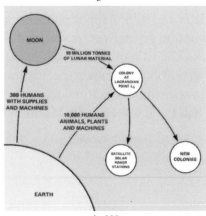

fig. 223

MOON CONSPIRACY

In 1976, Bill Kaysing, a former senior technical writer for the company that built the engines on the Saturn V rocket, self-publishes *We Never Went to the Moon: America's Thirty Billion Dollar Swindle*. In his book, Kaysing introduced arguments, which he said proved

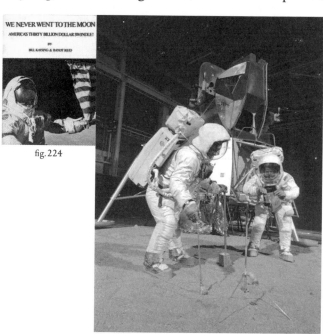

fig. 224

fig. 225

the Moon landings were faked and initiates the Moon hoax movement. The Moon landing conspiracy theories claim that some, or all, elements of the Apollo program and the associated Moon landings were hoaxes staged by NASA with the aid of other organizations.

VOYAGER

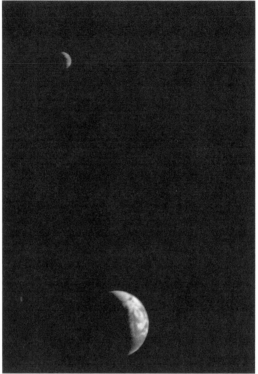

fig. 226

In September 1977 NASA launches *Voyager 1* to study the outer Solar System. The space probe communicates with the Deep Space Network to receive routine commands and return data back to Earth. *Voyager 1* takes the first-ever photograph of crescent-shaped Earth and Moon in one, single frame, 11.66 million kilometers (7.25 million miles) away from Earth.

SOUNDS OF EARTH

fig. 227

The Voyager space probe carries a gold-plated audio-visual disc in the event that either spacecraft is ever found by intelligent life forms from other planetary systems. The discs carry photos of the Earth and its life forms, a range of scientific information, spoken greetings from world leaders, such as the Secretary-General of the United Nations and the President of the United States, and a medley. A disc recording, *Sounds of Earth* is also included that includes the sounds of whales, a baby crying, waves breaking on a shore, and a collection of music, including works by Mozart, Blind Willie Johnson, and Chuck Berry and Valya Balkanska. Other Eastern and Western classics are included, as well as various performances of indigenous music from around the world. The record also contains greetings in 50 different languages.

LUNAR ALPHABET

fig. 228

Argentine-born writer, visual artist and filmmaker Leondro Katz creates his *Lunar Alphabet* in 1978 . His alphabet comprises of twenty seven different transitions of the Moon and poetically reflects on the paradoxes between seeing and reading.

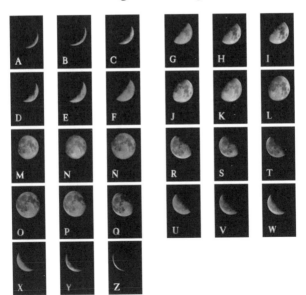

fig. 229

CAPRICORN ONE

Capricorn One is a government conspiracy thriller movie about a Mars landing hoax realized in 1978. It was written and directed by American director Peter

fig. 230

Hyams, who began thinking about a film of a space hoax while working on broadcasts of the Apollo missions for CBS. He later reflected regarding the Apollo 11 Moon landing, "There was one event of really enormous importance that had almost no witnesses. And the only verification we have…came from a TV camera." Despite the negative portrayal of the space agency, the filmmakers were able to obtain government equipment as props, including a prototype lunar module.

MOONRAKER

fig. 231

While Ian Fleming's fictional MI6 agent, James Bond, is saving the world in outer space aboard the Moonraker space shuttle, in the 11th spy film of the James Bond series, the *Agreement Governing the Activities of States on the Moon and Other Celestial Bodies* known as the *Moon Treaty* or *Moon Agreement* is formulated as an international treaty that turns jurisdiction of all celestial bodies over to the wider international community. In practice it is a failed treaty as it has not yet been ratified by any nation that engages in self-launched manned space exploration, or has plans to do so, since its creation in 1979.

ALIEN ANCESTORS

fig. 232

A year previously, in 1978, French scientist, Maurice Chatelain, who designed some of the communications system for NASA's Apollo program, publishes *Our Ancestors Came From Outer Space*. In his book, Chatelain asserts that the discovery of UFOs on the Moon is widely known among NASA personnel, but not publicly discussed. He claims that Armstrong and Aldrin have reported seeing two UFOs on the rim of a crater. Yet, Apollo 11's transmissions were sometimes interrupted to avoid transmission to the public.

SPACE INVADERS

fig. 233

By 1980, American citizens have spent more money playing the arcade video game *Space Invaders* than they did on the entire Apollo space program. The estimated $ 25 billion that the Apollo program cost equals around $ 120 per American citizen over the course of the lunar program's existence, or $ 13 per year of the program.

MTV MOON MAN

fig. 234

MTV's first moments on television in 1981 begin with an iconic image: the man on the Moon with an MTV flag. The "Moon Man" becomes the statuette given out at the MTV Video Music Awards.

TOURIST GUIDE TO THE MOON

Isaac Asimov publishes the article *A Tourist Guide to the Moon* in the New York Times in 1982, in which he portrays the colonization and appropriation of the Moon by tourists in 2082: "There are 50,000 people who consider themselves lunarians and accept the Moon as their home, and of these over 5,000 have been born on the Moon and never visited Earth. Almost all of them live in Luna City, the chief town."

SPACE CAMP

fig. 235

The Space Camp is founded in 1982 as an educational program for children using the U.S. space program as a way of educating children in space science. The concept for the camp is inspired by the forward-thinking ethos of von Braun, who feels that there is a need for a more engaging program that would encourage and motivate young people to consider a career in the aerospace industry. Each day at Space Camp begins with lessons in rocket science and propulsion, and exercises in NASA astronaut microgravity and disorientation simulators, underwater assembly of space hardware, model rocket launch, and mission training.

MAN ON THE MOON

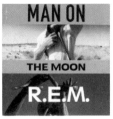

fig. 236

Man on the Moon (1982) by the rock band, R.E.M. is released as a tribute to the performer and comedian, Andy Kaufman. The song's title and chorus refer to the Moon landing conspiracy theories.

MICHAEL'S MOONWALK

fig. 237

Michael Jackson executes his signature moonwalk move for the first time during the Motown 25th anniversary television special in 1983. The dance move—reminiscent of the original astronaut's first steps on lunar ground—creates the illusion of the dancer being pulled backwards while attempting to walk forwards.

LUNACRETE

Larry A. Beyer proposes the idea of Lunacrete, also known as Mooncrete, in 1985 as a hypothetical aggregate building material—similar to concrete and formed from lunar regolith—that would reduce the construction cost of building on the Moon.

LUNAR EMBASSY

In the 1980's, Dennis Hope, an American entrepreneur, files a claim of ownership for the Moon and the other eight planets and their moons, based on an alleged loophole in the 1967 UN Outer Space Treaty. Despite a lack of response from the UN, Hope starts his own business, the Lunar Embassy Commission in 1980, to sell extraterrestrial real estate. By 2013, he has sold more than 600 million acres of land on the Moon alone. Property purchases start at a single acre

fig. 238

(4,000 square meters) as the smallest property unit available, and increases to enormous units the size of entire continents: approximately 5,000,000 acres (20,000,000,00 square meters) in size.

PEACE ON EARTH

fig. 239

In the 1987 novel, *Peace on Earth* by the Polish science fiction and philosophy writer, Stanisław Lem, all weapons development and production is moved to the Moon, with the aim of preventing human self-destruction on Earth and achieving the long sought-after dream of world peace. Eventually, the story tells how conflicts with robotic machines that handle the weapons beneath the Moon's surface lead to a total discontinuation of any communication with the Moon.

LUNA LUNA

fig. 240

The *Luna Luna* project—a combination of a bizarre amusement park and an avant-garde contemporary art show, conceived by Austrian artist and cultural manager, André Heller—takes place in Hamburg in 1987. American artist and social activist, Keith Haring, creates a colorful carousel for *Luna Luna* as a single spread pop-up and a life-sized carousel. In an annotation to the work, Haring reads: "*Luna Luna* in the sky. Will you make me laugh or cry?" thereby articulating the double-sidedness of the Moon and what our lunar satellite means to us.

WARHOL'S MOONWALK

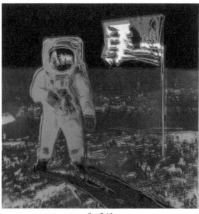

fig. 241

Only months before his death, Andy Warhol produces two moonwalk silkscreen images to commemorate the momentous achievement of the first man on the Moon. The image depicts the iconic photograph of astronaut, Buzz Aldrin, standing on the Moon printed in vibrant colors.

J. G. BALLARD

MEMORIES OF THE SPACE AGE

fig. 242

A collection of science fiction stories by English author J. G. Ballard entitled *Memories of the Space Age* is published in 1988. One of the stories in the book called "The Man Who Walked on the Moon", tells the strange tale of identity transference between an unnamed narrator, a jaded journalist, and Scranton, a beggar who scams tourists for money on Copacabana Beach by pretending to be an ex-astronaut. The journalist starts to see through Scranton's eyes and finally takes Scranton's spot on the beach, begging for money in exchange for his "tales from space".

PAUL AUSTER

MOON PALACE

fig. 243

Moon Palace, a novel by American author, Paul Auster, published in 1989, tells the story of an orphan child in the 1960s that spans three generations. The narrative moves from the early years of this century, all the way to the first lunar landings, from Manhattan to the landscape of the American West. Auster explains that the meaning of the Moon in his novel is many things simultaneously and is a touchstone in the novel. It represents the human desire for transcendence as well as American history: "First, there's Columbus, then there was the discovery of the West, then finally there is outer space: the Moon as the last frontier. But Columbus had no idea that he'd discovered America. He thought he had sailed to India and to China. In some sense *Moon Palace* is the embodiment of that misconception, an attempt to think of America as China."

AL REINERT

FOR ALL MANKIND

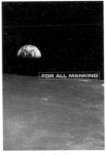

fig. 244

Directed by American filmmaker, Al Reinert, the documentary film, *For All Mankind*, with music by legendary British composer, Brian Eno, is released in 1989 to commemorate the twentieth anniversary of the first steps taken on the Moon. The film provides 80 minutes of NASA footage, taken from six successful Apollo lunar landing missions during the 1960s and 1970s. Six million feet of previously unpublished film footage, and 80 hours of NASA interviews are sifted through in the creation of this collage-like documentary. The film's score, originally composed in 1983 by Brian Eno, is released as an album entitled *Apollo: Atmospheres and Soundtracks*. On learning that most of the Apollo astronauts took recordings of country and western music with them into space, Eno included some "zero-gravity country music," with slide guitar sunk deep into long reverberations, a sonic metaphor for the vast emptiness of space.

INFLATABLE HABITAT

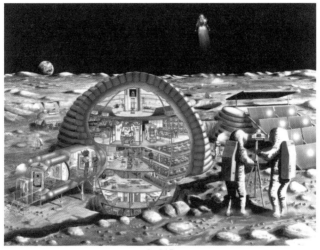

fig. 245

NASA continues to study possible lunar expeditions and to examine concepts for living and working on the surface of the Moon. Evaluations at Johnson Space Center by the Man Systems Division and Johnson Engineering staff, propose a 16-meter-diameter inflatable dwelling that could accommodate the needs of a dozen astronauts.

LUNAR REGOLITH

fig. 246

As the demand for actual Moon dust for scientists to study and to conduct experiments with exceeds the very limited stocks on Earth, NASA and the Johnson Space Center license the production of a synthetic simulant in 1994. The lunar regolith simulates terrestrial materials synthesized in order to approximate the chemical, mechanical, and engineering properties of lunar regolith.

LOST MOON

Apollo 13 Commander, Jimi Lovell with Jeffrey Kluger write *Lost Moon* in 1994. The book is about the dramatic failure of the Lunar landing mission in 1970 that nearly cost the lives of the three astronauts on board.

fig. 247

fig. 248

A year later, in 1995, a cinematic adaptation of the famous mission is released, by American director, Ron Howard, which is based on Lovell's book. The movie *Apollo 13*, co-written with *For All Mankind's* Al Reinert, features Tom Hanks in the lead role, acting as Jimi Lovell. The latter appears as captain of the Apollo recovery ship; Howard intends to make him an admiral, but humble Lovell himself, having retired as a captain, chose to appear as his actual rank. In the film, television networks in 1970 are depicted as barely interested in the Apollo mission, according to one of the Apollo astronauts: "The networks dumped us—one of them said going to the Moon is about as exciting as going to Pittsburgh."

CLEMENTINE

The Clementine Satellite, a joint space project between the Ballistic Missile Defense Organization and NASA is launched to make scientific observations of the Moon. The project is named after the song *Oh My Darling, Clementine* as the spacecraft would be "lost and gone forever" following its mission.

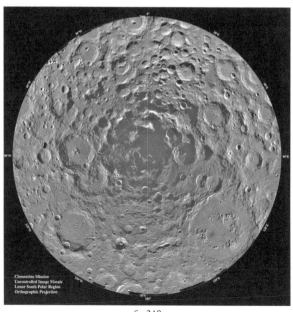

fig. 249

FIRST CONTACT

Star Trek: First Contact, releases in 1996 portraying the idea of possible lunar colonization. In the movie, approximately 50 million people live on the Moon: on a clear day, a few cities and man-made Lake Armstrong are visible on Earth. In one scene the time-travelling Stark Trek officer, William Riker, marvels at the sight of the "unspoiled" Moon in 2063.

fig. 250

EUROMOON 2000

In the 1990s, the European Space Agency (ESA) initiates the project *Euromoon 2000,* aiming to land a robotic craft near the Moon's south pole in the year 2000. Planned as a highly publicized mission, *Euro-*

fig. 251

moon 2000 is to attract the interest of school children, older students, and the general public. The estimated cost of the mission is "just" one euro per European citizen, thereby giving Europe an opportunity of being a significant partner in the establishment of the first extraterrestrial human outpost on the Moon. Unfortunately the investment capital needed for the mission, comprised of two spacecrafts, a lunar orbiter, and a lunar lander cannot be raised.

JUSTICE LEAGUE

Once again the Moon features as the futuristic backdrop in a superhero comic. Debuting in 1997 in the *Justice League of America* series, the Earth's Moon serves as the location of the *Justice League Watch-*

fig. 252

tower. The tower is constructed with promethium using highly advanced technologies from Earth and Mars. Supervillain, Lex Luthor, destroys the lunar watchtower.

219

TRUMAN SHOW

fig. 253

Peter Weir's 1998 satirical science fiction film, *The Truman Show*, gives the concept of the man on the Moon another interesting twist. The film depicts the life of Truman Burbank, the unsuspecting star of the *The Truman Show*, a reality television program in which his entire life, since before birth, is filmed by thousands of hidden cameras, 24 hours a day, 7 days a week, and broadcast live around the world. In this constructed reality, the godlike director and creator of the show controls everything from his lunar room inside the faux Moon on the gigantic studio set.

FROZEN WATER

In 1998, NASA scientists working on the Lunar Prospector mission, announce tentative findings of the presence of frozen water in craters near the Moon's south and north poles. These findings are based on reasonable scientific assumptions made from the levels of hydrogen detected on the Moon. As much as 200 million metric tons of frozen water is estimated to exist at the poles.

TRANSIENT LUNAR PHENOMENA

fig. 254

The Lunar Prospector spacecraft also measures recent emissions of radon gas near the prominent lunar impact crater known as Aristarchus. This area is also known for the great number of reported transient lunar phenomena. A transient lunar phenomenon (TLP) is a strange, short-lived light or color change in the appearance of the surface of the Moon. Claims of short-lived lunar phenomena date back at least 1,000 years, with some having been observed independently by multiple witnesses or by reputable scientists. Of the most reliable of these events, at least one-third come from the vicinity of the Aristarchus plateau—often as a glow of electric purple-blue. Both Apollo 11 and Apollo 15 missions in 1969 and 1971 observed irregularities in this area. Apollo 11 noticed an illuminated field with slight amounts of fluorescence, while the Apollo 15 detected a significant rise of particles as it passed 110 kilometers above the plateau. Lunar conspirators suspect alien fusion reactors.

221

FUTURAMA

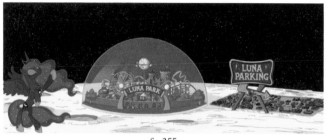

fig. 255

On the thirtieth anniversary of the lunar landings in 1999, remarkably little official celebrations take place. However, the cartoon series *Futurama* airing for the first time pays tribute to the lunar neglect at the end of the twentieth century in its second episode "The Series Has Landed". In the episode, the newly assembled crew of delivery company employees are charged with delivering a package to a theme park on the Moon. By the year 3000, a theme park is constructed on the Moon inside a giant dome with an artificial atmosphere and artificial gravity. For the main character, Fry—a loser who accidentally cryogenically froze himself at the turn of the millennium in 1999 and wakes up in the year 3000—traveling to the Moon is initially an exciting thought, but he is then disappointed by his visit: "The Moon was like this awesome, romantic, mysterious thing, hanging up there in the sky where you could never reach it. No matter how much you wanted to. But you're right, it's just this big, dull rock."

EYES WIDE SHUT

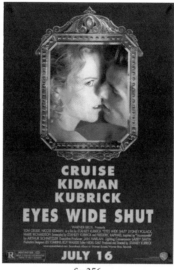

fig. 256

A few months after Stanley Kubrick's death, his last film *Eyes Wide Shut* is released on July 16, 1999. Kubrick stipulated that the movie had to open on that particular date: the thirtieth anniversary of the first landing on the Moon. Could it have been a final message of the director who's rumored to have staged the landing on the Moon for NASA in 1969?

FIRST WOMAN ON THE MOON

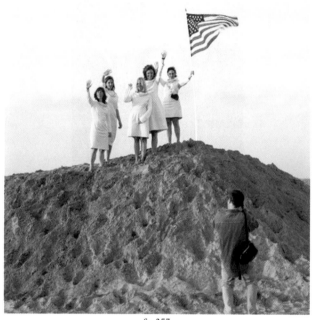

fig. 257

For her performance entitled, *First Woman on the Moon* (1999), Aleksandra Mir enacts a Moon landing on a beach in the Netherlands. Against an industrial backdrop, Mir, dressed in a smart white dress, and with an American flag in hand, scales the side of a moonscape of sand dunes and makeshift craters. Her performance deconstructs the popular cultural myth and historical event of the lunar landings into a make-believe world of her own.

HABOT

By the beginning of the new millennium, John Mankins presents his *Habot*—a contraction of the words "habitat" and "robot"—concept. It constitutes an innovative approach that combines the exploration capabilities of humans and robotics. The *Habot* concept consists of a mobile habitat that lands autonomously on a specific

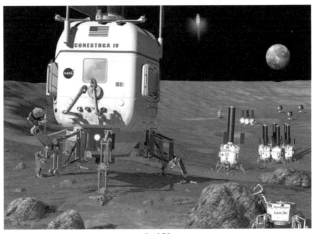

fig. 258

landing zone on the Moon. From there, with the use of its own power, it moves to a lunar base site. The baseline number of crew missions is 10 for a total planned crew-time of 560 Earth-days, and with a total capability for 100 crew-days on the Moon during the missions.

225

MOON ESTATES

Dennis Hope, founder of the Lunar Embassy Commission, goes online with *Moon Estates* in 2001 to continue to sell lunar real estate, at approximately 20 euros for a small football-field sized property. More

fig. 259

than 1,800 major corporations purchase property from them with specific project intentions, including the Hilton and Marriott hotel chains.

HANS-JÜRGEN ROMBAUT

LUNAR HOTEL

fig. 260

Dutch architect Hans-Jürgen Rombaut's project, *Lunar Hotel*, proposes the construction of a 160-meter-high hotel on the surface of the Moon for approximately 200 guests and with a staff matched in proportion. Located in one of the Moon's canyons, the hotel would take full advantage of the depth of the canyon site.

AURORA

fig. 261

Established in 2001 by the European Space Agency, the human spaceflight program, Aurora, addresses robotic and human exploration on the Moon and Mars. A secondary objective is to search for life beyond the Earth.

X-FILES

fig. 262

Fox television broadcasts the hour-long documentary, *Conspiracy Theory: Did we really land on the Moon?* hosted by X-Files presenter, Mitch Pileggi. The documentary claims that NASA faked the first lunar landing in 1969 in order to win the Space Race. Polls taken in various locations have shown that between 6% – 20% of Americans surveyed believe that the manned lunar landings were actually faked. This percentage rises to as high as 28% in Russia.

A FUNNY THING

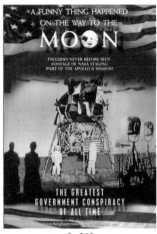

fig. 263

The show immediately gives a platform to several advocates of the conspiracy theory. One of them, American filmmaker, Bart Sibrel, directs two documentaries on the subject: *A Funny Thing Happened on the Way to the Moon* (2001) and its follow-up *Astronauts Gone Wild* (2004). In 2002, Sibrel lures Buzz Aldrin—the second man to walk on the Moon— to a Beverly Hills hotel under the pretext of making an interview for a Japanese children's television show. 82-year-old Aldrin clobbers Sibrel in the jaw after the latter approaches the former astronaut and demands him to swear on the Bible that the landing was not staged. No charges are filled.

TRUE LIES

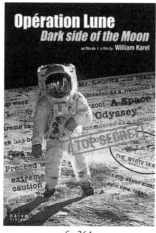

fig. 264

In 2002, the Franco-German TV Network, Arte, airs the French "mockumentary" film *Dark Side of the Moon* by director, William Karel. The basic premise for the film is the theory that the television footage from the Apollo 11 Moon landing was faked and that the footage was actually recorded in a studio by the CIA with help from the director, Stanley Kubrick. Between lies and truths, the film mixes actual facts and fiction and features some surprising guest appearances, most notably by Donald Rumsfeld, Henry Kissinger, Buzz Aldrin, and Stanley Kubrick's widow, Christian Kubrick.

MOONHOUSE

The moonhouse art project, led by Swedish artist and entrepreneur Mikael Genberg aims to democratize space exploration by bringing man closer to Earth's nearest celestial body, the Moon. The crowd funding initiative proposes to install a self-assembling house

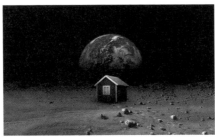

fig. 265

on the moon, which will be sent up in October 2015 on spaceX's Falcon spacecraft. Designed by American aerospace company Astrobotic, the nine m² red building—trimmed with white fascia, windows and a front door—will bring the barren, dead moonscape to life for the first time in history. The house is currently 75% engineered to spec, and will be outlined by a thin sheet of specially developed space-cloth, which will be stretched over a carbon frame. Once placed on the Moon, the installation will construct itself as it is filled up with gas. This means that the structure, which holds the house up and shapes the construction, can correct itself, automatically sealing itself from any leaks.

JOURNEY TO THE MOON

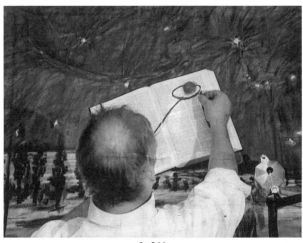

fig. 266

Fascinated by George Méliès science fiction film *Le Voyage dans la Lune* from 1902, the South-African artist William Kentridge creates, with his work of the same name, an homage to the French experimental filmmaker Georges Méliès, combining live action and stop motion animation.

VISION OF THE FUTURE

U.S. President George W. Bush announces in his State of the Union speech in January 2004 a vision of future

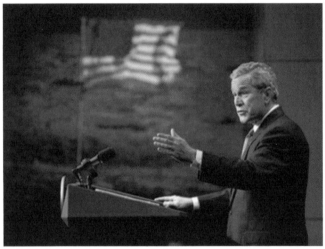

fig. 267

space exploration to "establish an extended human presence on the Moon" by 2020. To reduce the costs for further space exploration, Bush proposes the "harvesting and processing of lunar soil into rocket fuel and breathable air."

SMART 1

The European Space Agency launches its space satellite, *SMART-1*, the first of ESA's Small Missions for Advanced Research in Technology in 2004. The satellite travels to the Moon using solar-electric propulsion

fig. 268

and carries a battery of miniaturized instruments. As well as testing new technology, *SMART-1* undertakes the first comprehensive inventory of key chemical elements on the lunar surface. It also investigates the theory that the Moon was formed following the violent collision of a smaller planet with Earth, 4.5 billion years ago.

VIRGIN GALACTIC

fig. 269

In 2004, British business tycoon and investor, Sir Richard Branson's Virgin Group and American aerospace engineer, Burt Rutan, establish Virgin Galactic, a commercial spaceflight company. Virgin Galactic plans to provide suborbital flights to space tourists, suborbital launches for space science missions, and orbital launches of small satellites.

CRAWLER

American artist, Tom Sachs, starts his long-lasting artistic investigation of space travel in 2003 with a 1:25 scale, foam-core sculpture he entitles *Crawler* and the ink-on-paper drawing, *U.S. Space Suit* in 2005.

fig. 270

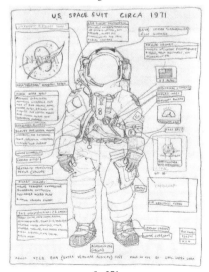

fig. 271

END
OF THE MOON

As NASA artist-in-residence, American experimental performance artist and musician, Laurie Anderson produces a 90-minute monolog called *The End of the Moon*, fueled by visions of inner and outer space. The show has a New York premiere for a two-week run in 2005.

fig. 272

BILLIONAIRE
BOYS CLUB

fig. 273

Musician and space fanatic, Pharrell Williams along with Japanese fashion designer Nigo, founder of clothing label, A Bathing Ape, establish the clothing line, Billionaires Boys Club in 2005. The visual language of the new range is directly inspired by iconographic imagery surrounding the Apollo Moon flights. The brand's logo depicts a stylized illustration of an astronaut.

The first Billionaire Boys Club flagship store, designed by Masamichi Katayama's interior design firm Wonderwall, opens in New York City in 2007. The store's entire interior is inspired by the space age. Reproductions of NASA photographs of lunar landscapes adorn the floor, while colorful star motifs embellish the dark walls.

fig. 274

PERMANENT BASES

In December 2006, NASA announces its intention to begin building a permanent base on the Moon by 2024. Crews and materials will be launched from Earth by Ares V rockets and will travel to the Moon aboard Orion spacecraft and automated transport vehicles. Russia's booster rocket manufacturer, Energia, has an even more ambitious program: to build a permanent base on the Moon by 2015. They did not succeed.

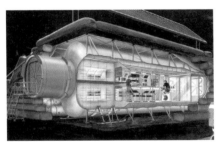

fig. 275

FLY ME TO THE MOON

Dutch artists Bik Van der Pol take as the core item for their project *Fly me to the Moon* one of the oldest objects in the collection of the Rijksmuseum in Amster-

dam: a moon rock. The crew of the first manned lunar landing mission, Apollo 11, brought this rock back to earth in 1969. That same year the three astronauts Neil Armstrong, Edwin Aldrin, and Michael Collins

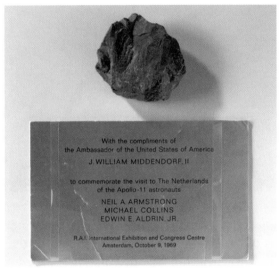

fig. 276

visited the Netherlands. Willem Drees, a former Dutch prime minister, received the rock on that occasion as a present from the United States ambassador. And later, this piece of stone was donated to the Rijksmuseum. The moon rock creates links between the site of the museum, the city, the collection and its own origins. These links are examined from various perspectives. In the background are questions concerning the public and private significance of a collection, as well as questions of public interest. In 2009 it turns out that the moon rock is just a piece of petrified wood.

SPACE PROGRAM

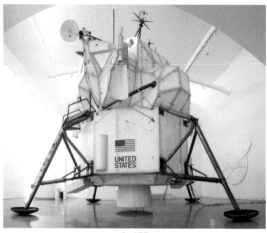

fig. 277

Tom Sachs's ingenious contemporary artistic interpretation of the Apollo program culminates in the creation of his own, life-size installation entitled *Space Program*. The exhibition opens in 2007 and recollects the lunar landings, an historic event that holds our collective memory, as a custom-made experience from the domain of public imagination. In addition to his 1:1 installation, Sachs builds an intricate lunar module as its centerpiece: replete with such classic "Sachsian" features as a fully-stocked liquor cabinet, toolkit, and soundtrack necessary for survival on an alien planet. Visitors can also experience a fully functioning mission-control unit. The liturgy of space exploration unfolds on a grid of monitors in a live demonstration by Sachs and his team, involving countless rituals and procedures, from instrument checks to moonwalking, and

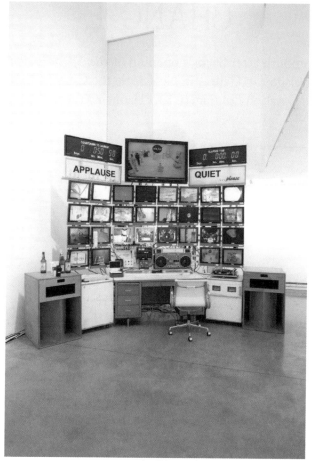

fig. 278

to wash down a collection of lunar samples. Thus, the gallery becomes a sort of reliquary of both the material traces and special effects of the artist's encounters with the sublime.

243

CHANG'E

A month after Sachs's opening of the *Space Program* in Gagosian Gallery in New York, the Chinese Lunar Exploration Program (CLEP) launches the first space-

中国探月
CLEP

fig. 279

craft of the program, the Chang'e 1 lunar orbiter. The Chang'e program is an ongoing series of robotic Moon missions by the China National Space Administration (CNSA). The program incorporates lunar orbiters, landers, rovers, and sample return spacecrafts. Two years later, Chang'e 1 crashes into the surface of the Moon, abruptly ending its mission. China intends to launch a lunar base and an unmanned space probe to the Moon by 2010. While the first mission has not been accomplished yet, the later was successful.

GOOGLE LUNAR X PRIZE

fig. 280

The Google Lunar X Prize (GLXP) sometimes referred to as Moon 2.0 is announced at the Wired Nextfest in 2007. The $ 20 million space competition is organized by the X Prize Foundation and is sponsored by Google. The challenge calls for privately-funded spaceflight teams to compete in successfully launching a robotic spacecraft that can land and travel across the surface of the Moon while sending back images and other relevant data to Earth.

RUINS ON THE MOON

fig. 281

In 2007, the former manager of the Data and Photo Control Department at NASA's Lunar Receiving Laboratory during the manned Apollo Lunar Program, Ken Johnston, releases a number of sensational statements. The specialist pilot claims that American astronauts found ancient ruins of an artificial origin and previously unknown technology to control gravitation when the Apollo landed on the Moon. NASA dismisses Johnston and denies the allegations.

SHACKLETON CRATER

fig. 282

NASA names the rim of Shackelton, an impact crater that lies on the South Pole of the Moon, as a potential candidate for its lunar outpost, where they'll conduct scientific research, as well as test technologies and techniques for possible exploration of Mars and other destinations.

SPACE PROJECT

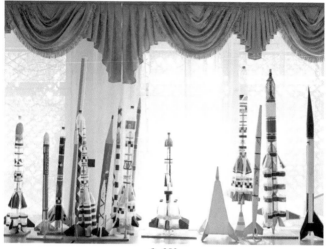

fig. 283

Inspired by Jules Verne, Belgian photographer, Vincent Fournier, visits a variety of locations that are associated with space travel. His ongoing *Space Project* (2007) is a photographic archive of the most representative space organizations in the world, ranging from the Gagarin Cosmonaut Training Center near Moscow, the Mars Desert Research Station in Utah, observatories in the Atacama Desert, and the Guyana Space Center in French Guiana.

fig. 284

fig. 285

O MOON

Chandrayaan 1, India's first unmanned lunar probe—including a lunar orbiter and an impactor—is successfully launched by the Indian Space Research Organisation in 2008. The Indian Space Research Organisation carries the following verse from the Rig Veda: "O Moon!/ We should be able to know you through/ our intellect, You enlighten us through the right path."

fig. 286

fig. 287

MOON GOOSE EXPERIMENT

German artist, Anges Meyer-Brandis's *Moon Goose Experiment (MGE)* takes place in Siberia in 2008. The experiment is based on an excerpt from Francis Godwin's *Man in the Moone* (1638), in which the protagonist flies to the Moon in a chariot towed by "gansas" birds, more commonly known as geese. These special Moon geese migrate every year from Earth to Moon. The artist observes the effect that a total eclipse of the Sun has on the behavior of the Moon geese from an island in River Ob in Siberia.

EARTH-MOON-EARTH

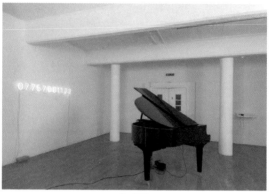

fig. 288

Scottish artist, Katie Paterson, known for her multidisciplinary and conceptually driven work, creates *Earth-Moon-Earth (E.M.E.)*, a form of radio transmission whereby messages are sent in Morse code from Earth, reflected from the surface of the Moon, and then received back on Earth. The Moon reflects only part of the information back, whilst some is absorbed in its shadows, or vanishes in its craters. For this work Beethoven's *Moonlight Sonata* is translated into Morse code and sent to the Moon via *E.M.E.* Returning to Earth fragmented by the Moon's surface, it is translated into a new score, the gaps and absences becoming intervals and rests. In the exhibition space the new moon-altered score plays on an auto-playing grand piano.

252

LUNAR RECONNAISSANCE ORBITER

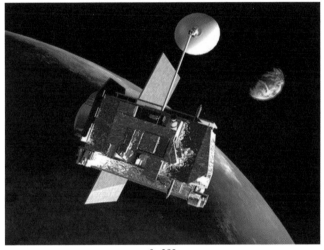

fig. 289

In the summer of 2009, NASA launches the Lunar Reconnaissance Orbiter (LRO) and the Lunar Crater Observation and Sensing Satellite (LCROSS). The first is a robotic spacecraft that orbits the Moon and photographs the surface of the Moon's poles in search of ice and frost. The LCROSS manages to discover water molecules on the Moon by crashing a rocket into the Moon and then analyzing the debris left on the rocket.

LUNA RING

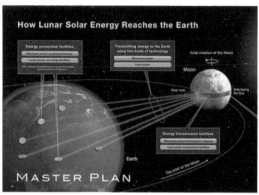

fig. 290

The Japanese Shimizu Corporation presents their *Luna Ring* concept, which proposes lunar solar power generation as the ultimate source of green energy. Electric power is generated by a belt of solar cells around the lunar equator, which is transmitted and beamed to the Earth from the near side of the Moon: the side that always faces Earth.

fig. 291

MOON

fig. 292

David Bowie's son, Duncan Jones, shares his father's fascination with space travel and releases the claustrophobic science fiction film *Moon* as his feature debut in 2009. Set in the year 2035, the movie follows the protagonist, a Lunar Industries employee who experiences a personal crisis as he nears the end of a three-year solitary stint mining helium-3 on the far side of the Moon.

MAD MEN

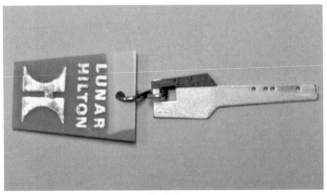

fig. 293

An episode of the popular TV series *Mad Men* in 2009 features the louche protagonist Don Draper and his team creating a fictional ad campaign for a Hilton Hotel on the Moon. "I want a Hilton on the Moon; that's where we are headed," says Conrad Hilton at one point.

LOST ASTRONAUT

As part of the Performa 09 biennial, Alicia Framis presents *Lost Astronaut,* a performance installation about a speculative discussion, in which she looks at the idea of a journey to the Moon, the evolution of architecture and interiors for space travel, as well as our thoughts and experience of the Moon. Equipping herself with a real astronaut suit, Framis spends 15 days wandering the streets of New York following the instructions by 15 artists and writers—from train stations to libraries—eager to convey the poetry, the humor, and the parody of history, as well as the imaginative possibilities for architecture and design on the Moon.

fig. 294

MOON LIFE

fig. 295

Framis continues her lunar work with the Moon Academy and the Moon Life Concept Store the following year in Amsterdam and Shanghai. The idea is to provide new impetus for multi-disciplinary knowledge exchange in the field of space technology and related disciplines with architects, artists, and designers. Her *Moon Life* Catalogue appears as a supplement in the "Getting There Being There" issue of the architecture magazine Volume, an issue entirely dedicated to space

and Moon travel and its implications for the design practice. The *Moon Life* Catalogue offers products for daily life on the Moon designed by various professional artists, architects, and designers.

PRIVATE MOON

Russian artist, Leonid Tishkov's *Private Moon* tells the story of a man who met the Moon and stayed with her for the rest of his life. In a series of photographs, the artist pairs images of his private Moon with passages of verse which describe how the Moon helps us to overcome our loneliness in the universe by uniting us around it.

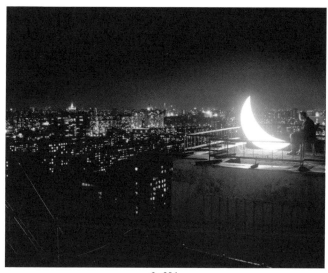

fig. 296

fig. 297

OBAMA

Subsequent to the realization that NASA's plan to return to the Moon could not be executed without substantial increases in funding, American President, Barack Obama announces a proposal to cancel the program by 2011. Shortly thereafter he announces changes to the proposal in a major space policy speech at Kennedy Space Center in 2010: "Fifty years after the creation of NASA, our goal is no longer just a destination to reach. Our goal is the capacity for people to work, and learn, and operate, and live safely beyond the Earth for extended periods of time, ultimately in ways that are more sustainable and even indefinite."

LA MORT D'UN CHAT SUR LA LUNE

In 2010, The Simpsons episode *Moe Letter Blues* includes the interlude with fictional animated television series *Itchy and Scratchy* delivers an affectionate pastiche of George Méliès' *Le Voyage dans la Lune*. Titled *La Mort d'un Chat sur la Lune (The Death of a Cat on the Moon)*, the skit begins with Scratchy the cat acting as cameraman for Itchy's film of a trip to the Moon. The camera runs out of film, and the furious director slices open the cat's belly and loads his intestines into the camera like a filmstrip.

fig. 298

fig. 299

DESPICABLE ME

fig. 300

In the 2010 American, computer-animated comedy film, *Despicable Me,* the supervillain, Gru decides to steal the Moon in an attempt to prove himself better than his arch-rival supervillain, Vector.

LUNAR SPHERE HOUSE

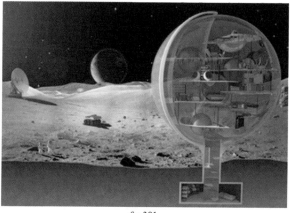

fig. 301

Royal Haskoning conceptualizes a house that is a transparent sphere, a living spaces for lunar residents, offering inhabitants unlimited views of the awe-inspiring setting of the lunar landscape. A protective screen rotates around the sphere to protect the inside from the harsh rays of the Sun. The sphere is envisioned as a mini-Earth with its own oxygen supply and various levels that inhabitants can simply float between rather than taking stairs.

DARK OF THE MOON

In 2011, the American science fiction, action film, based on the Transformers toy series releases the third installment in the series; *Transformers: Dark of the Moon.* Here, the 1969 Apollo 11 mission to the

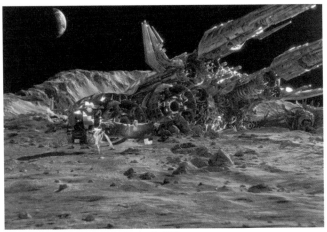

fig. 302

Moon turns out to be a top-secret mission to examine the remains of an ancient Transformer spacecraft containing deceased alien robots.

GONZALO LÓPEZ-GALLEGO
APOLLO 18

fig. 303

The premise of the 2011 science fiction horror film, *Apollo 18,* directed by Gonzalo López-Gallego, is that the canceled Apollo 18 mission actually landed on the Moon in December 1974, but never returned, and as a result the United States has never launched another expedition to the Moon. The film is shot in "found-footage" style, supposedly the recently discovered lost footage of the Apollo 18 mission.

265

IRON SKY

fig. 304

Inspired by Robert A. Heinlein's 1947 science fiction novel *Rocket Ship Galileo*, the partially crowd-founded sci-fi comedy, *Iron Sky,* is released in 2010. Directed by Timo Vuorensola, the film tells the story of a group of German Nazis who, having been defeated in 1945, fled to the Moon where they build a space fleet, and later returning to conquer the Earth in 2018.

SILO

Brian Harms and Keith Bradley from the California Polytechnic State University design a stadium for the Moon. SILO – Stadium International Lunar Olympics has everything for the Olympic Games including a hotel, restaurants and a solar electric system. The play-

ing field will be 0.5 kilometers in diameter and with a seat count of around 100,000. The Lunar Stadium

fig. 305

aims to improve existing sports and also invent some new ones. The gravity on the Moon is different from that on the Earth and it allows to jump higher but run slower. Harms and Bradley: "Within the lunar colonies of the future, recreational activities will arise and evolve to take advantage of the moon's micro-gravity. The sports we know today will be modified, and brand new sports will be invented. Lunar sports associations will be created, teams will be sponsored, games will be televised, and people from all over the globe will watch as the best of the best compete in an arena in which all the rules have changed."

MOON GOOSE COLONY

fig. 308

Based on her 2008, *Moon Goose Experiment*, German artist, Agnes Meyer-Brandis, realizes her concept for the *Moon Goose Colony (MGC)*. Between 2010 and 2012 Meyer-Brandis raises 11 Moon geese from birth, giving them astronauts' names, taking on her role as goose-mother, training them to fly and taking them on expeditions and housing them in a remote Moon analog habitat.

fig. 307

WE COLONISED THE MOON

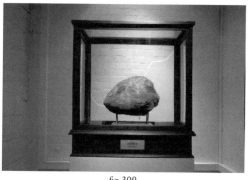

fig. 309

The artists Sue Corke and Hagen Betzwieser collaborate on the piece, *We Colonised the Moon*, which explores the gaps and connections between Art and Science. A silkscreened image, entitled *MOON scratch & sniff* is one example of their numerous lunar-inspired projects. It is imbued with the "smell of the Moon" as described by Apollo 16 astronaut, Charlie Duke in 1972: "It is really a strong smell. It has that taste—to me, gunpowder—and the smell of gunpowder too." In the work, *Enter at Own Risk*, a lone astronaut carefully tends a group of rocks, spraying them periodically with the "smell of the Moon," in a laboratory-like room. *A Billion Year Old Desert* is a series of experimental silkscreen prints of rocky lunar surfaces made from graphite powder. The approach is inspired by astronaut Don Pettit, who called the Moon a 4 billion-year-old desert; a metaphor for the dry and dusty nature of

the lunar surface. The installation, As *Good as Moon Rock* (2012) gives another twist to Moon exploration by working with the NASA licensed production of a synthetic simulant of Moon dust for scientific probes.

LAST LAUNCH

American photographer, Dan Winters's *Aerospace* series and lunar themed book, *Last Launch* power-

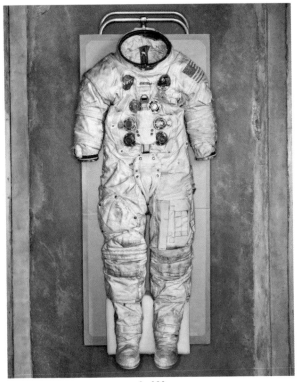

fig. 309

fully evokes the quest for new frontiers that "took us to the Moon and inspired dreams of setting foot on other planets and voyaging among the stars." Winters is one of only a handful of photographers to whom NASA gives close-range access to photograph the last launches of the Discovery, Atlantis, and Endeavour space shuttles.

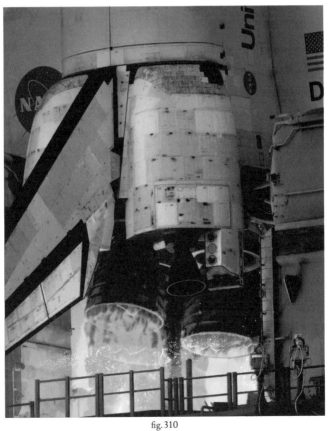

fig. 310

MOON DUST REMIX

fig. 311

In 2012, French experience designer, Nelly Ben Hayoun invites scientists to respond to the challenge of imagining the sound of Neil Armstrong's boots on the Moon for his work, *Moon Dust Remix*. From this she creates the soundtrack for *Moon Dust Remix*, a "Moon chorus" of lunar scientists. Working with the original footage from Apollo 11's mission in collaboration with foley artist, Sue Harding, Ben Hayoun engages with the challenge of fabricating lunar sound.

SPACE ORCHESTRA

fig. 312

Ben Hayoun also directs the International Space Orchestra at NASA's Ames Research Center in collaboration with Beck, Bobby Womack, Damon Albarn, Maywa Denki, Bruce Sterling, and Penguin Café. The orchestra is created and assembled during the Summer of 2012, with a team of space scientists from the NASA Ames Research Center, SETI Institute (search for extraterrestrial life), Singularity University, and the International Space University. Her work *Ground Control: An Opera in Space* performs recordings by the International Space Orchestra and is released from the International Space Station in 2013.

SECOND MOON

fig. 313

Second Moon, another work by Paterson, tracks the cyclical journey of a small fragment of the Moon as it circles the Earth via airfreight courier on a man-made commercial orbit. Orbiting at approximately twice the speed of our Moon, over one year *Second Moon* orbits the Earth 30 times. Furthermore, it is visualized through a free app that tracks the lunar meteorite in relation to the user's location, the Moon's location, and the orbits of the other planets in our solar system.

AFRONAUTICS

In *The Afronauts,* Spanish photographer, Cristina de Middel, expands on a little-known episode from Zambia's history: a space program started by the teacher Edward Makuka Nkoloso who unexpectedly entered Zambia in the Space Race with the United States and Russia. From 1960 until sometime after 1969, this program sought to accomplish the launching of a rocket that would send one girl, 17-year-old Matha Mwambwa, and two cats to the Moon. Due to a lack of financial resources, the pregnancy of astronaut Matha Mwambwa and her subsequent departure from the program to return to her parents, the ambitious initiative was doomed to failure. De Middel reconstructs this story 50 years later using her own imagination.

fig. 314

OUTER SPACE

fig. 315

In 2011, German artist, Michael Najjar begins a work entitled *outer space,* photographing the last launch of Atlantis space shuttle at Cape Canaveral. Three years later he has completed a large part of his astronaut-training program and is set to become the first artist to travel to outer space.

fig. 316

DOUBLE MOON

fig. 317

Clouds Architecture Office proposes *Double Moon* in 2012: an artificial twin Moon that hovers over the former site of the Pruitt-Igoe housing project in St. Louis, Missouri. A curious presence in the skyline, the incandescent orb spurs a discovery process for spectators. A beacon in the night, the double Moon orients inhabitants, marking this historic site to viewers around the city. During the day the interior of the Moon will be used as an auditorium, a venue for musical performances by groups such as the Northside Cherubim Youth Choir. The top of the globe would feature an observation deck. The Moon floats above the site of the former Pruitt-Igoe houses, leaving intact the 40-year-old wilderness that has taken root.

MOON

Harnessing the connective power of the internet, Danish-Icelandic artistst Olafur Eliasson and Chinese artist activist Ai Weiwei introduce *Moon,* an interactive project that transcends nationality, language, and even

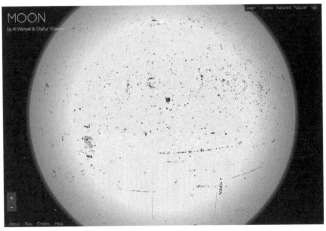

fig. 318

the physical world. The evolving collaboration represents the unlimited potential of the Internet to act as mass connector, including an open online interface where visitors can mark (almost like graffiti), explore, and even traverse through a digital moonscape.

FRACTAL LUNAR BASE

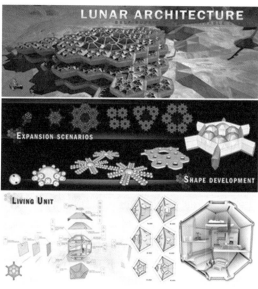

fig. 319

A fractal design for a lunar base by Hatem Al Khafaji of Dubai makes it easy to expand the available space as needed using a system of seven modular components of living pods, air locks, corridors and connectors. Layers of these modules would be placed around a central "heart" and continuously stacked by teams of robots and human workers. The design explores the new possibilities due to the Moon's low gravity, and the new structural force; the pressure force.

IN ORBIT

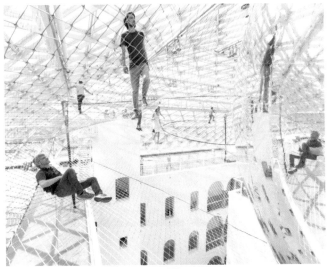

fig. 320

Argentinian artist, Tomás Saraceno's gigantic 2013 installation work, *In Orbit,* a suspended net construction within which visitors can move, seemingly weightlessly, also reflects upon floating in outer space. "I am reminded of models of the universe," says Saraceno about his work, "that depict the forces of gravity and planetary bodies." Talking about his *In Orbit* piece, the artist says, "proportions enter into new relationships; human bodies become planets, molecules, or social black holes."

LUCA GALOFARO

MOON BASES

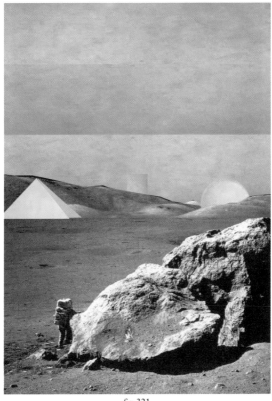

fig. 321

Luca Galofaro of Rome based multi-disciplinary archi-
tecture practice IaN+ releases a series of iconic collages
of fictional architectures on the Moon. The series is
based on his diploma at the International Space Uni-
versity in 1993 and new works that playfully reflect
upon the possibility of living on the Moon.

fig. 322

YUTU THE JADE RABBIT

Yutu (literally: "Jade Rabbit") is an unmanned lunar robot that forms part of the Chinese Chang'e 3 mission to the Moon. It is launched December 2013, and reaches the Moon's surface two weeks later. The mission marks the first soft landing on the Moon since 1976 and the first rover to operate there since the Soviet Lunokhod 2 ceased operations on 11 May 1973. The rover encountered operational difficulties after the first 14-day Lunar night, and was unable to move on the Lunar surface after the end of the second Lunar night, yet it is still gathering some useful data. The Moon rabbit in folklore is a rabbit that lives on the Moon, based on pareidolia that identifies the markings of the Moon as a rabbit. In Chinese folklore it is often portrayed as a companion of the Moon goddess Chang'e.

3D PRINTED LUNAR BASE

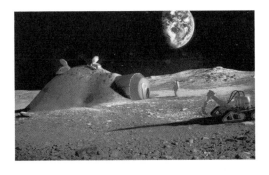

The British architecture practice Foster+Partners is part of a consortium set up by the European Space Agency to explore the possibilities of 3D printing to construct lunar habitations. Addressing the challenges of transporting materials to the Moon, the study is investigating the use of lunar soil, known as regolith, as a building material.

Foster+Partners has designed a lunar base to house four people, which offers protection from meteorites, gamma radiation, and high temperature fluctuations. The base is first unfolded from a tubular module that can be transported by space rocket. An inflatable dome then extends from one end of this cylinder to provide a support structure for construction. Layers of regolith are then built up over the dome by a robot-operated 3D printer to create a protective shell.

fig. 323

283

MINING
THE MOON

fig. 324

In February 2014, NASA announces that it accepts applications from American companies to build robots for lunar prospecting. NASA's project is known as CATALYST (Cargo Transportation and Landing by Soft Touchdown) and is entirely dependent on private sector financing. The idea is that NASA works with private enterprises to develop affordable methods of transport to, and from, the Moon. Companies that fund the project would be given first rights at extracting minerals from the Moon, whilst helping to expedite new exploration and science missions on the lunar surface.

Mining on the Moon and on asteroids is therefore clearly in the sights of governments and, increasingly, private companies. Many elements that are rare on Earth can be found in abundance on the Moon. Satellite imaging has shown that the top 10 centimeters of Moon soil at the south pole of the Moon appears

to hold about 100 times the concentration of gold from the richest mines in the world. Apart from rare Earth minerals such as platinum, rhodium, and gold, H_2O and Helium-3 are under special scrutiny for lunar extractions. The latter, Helium-3, is scarce on Earth and may be the key to fueling sustained, large-scale nuclear fusion reactions that could power entire cities.

VIRGIN'S MOON HOTEL

Aiming at being the first company in the world to have a building on the Moon, in 2014 Richard Branson reveals architectural designs by Virgin Buildings for a Moon hotel that looks like an elongated twisted tube. Eventually Branson's proposal of putting a hotel on the Moon turns out to be an April Fools' Day Joke.

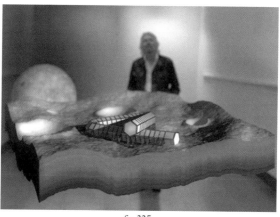

fig. 325

LUNAR90

Nike Sportswear releases a limited edition shoe to commemorate the 45th Anniversary of man walking on the Moon. The shoe features a full reflective upper with an all over Moon graphic covering it. Represent-

fig. 326

ing the American flag are red and white stripes on the back right heel paired with blue and white stars on the left heel.

LUNAR SURFACE

Created by Seoul based art and design studio Kimchi and Chips with photographer Eunyoung Kim, *Lunar Surface* is the latest in the series of projects investi-

fig. 327

gating digital light as in the representation of digital visual information in physical space. In this project, a vertical flag of fabric is stroked by the wind, displaced by curves of air pressure, swinging back and forth. As it sweeps it extrudes a trail of light, which draws a moon floating in space. Long exposure photography captures this invisible dimension of space, bringing the Moon into existence on a set of unique photographic prints.

A DISTANT VIEW

fig. 328

A Distant View by United Visual Artists is a series inspired by the first images captured by the original Lunar Orbiter missions in 1966–1967, prior to the Moon Landings. *A Distant View* reconstructs the reality as captured in the original photographs of the lunar surface. Light reveals the "shadows" of the data; the unseen landscapes in the photographs, hidden by technology and perspective. *A Distant View* turns these historical photographs into relief, bringing the unreachable within reach.

LUNAR MISSION ONE

Lunar Mission One is an inspirational and ambitious Kickstarter project, that aims to send an unmanned

fig. 329

robotic landing module to the South Pole of the Moon—an area unexplored by previous missions. Lunar Mission One aims to use pioneering technology to drill down to a depth of at least 20 m—10 times deeper than has ever been drilled before—and potentially as deep as 100 m. By doing this, Lunar Mission One will access lunar rock dating back up to 4.5 billion years to discover the geological composition of the Moon, the ancient relationship it shares with our planet and the effects of asteroid bombardment.

Ultimately, the project will improve scientific understanding of the early solar system, the formation of our planet and the Moon, and the conditions that initiated life on Earth.

FUTURE NOW

More than 40 years after humankind first sets foot on the Moon, interplanetary space travel has again entered the realm of the achievable.

Before the end of this decade, new Moon landing missions by various nations are scheduled to explore the Moon more intensively, set up a lunar base, and stay for extended periods of time.

A Moon settlement is no longer a sheer fantasy, but something that is seen by scientists around the world as the next step, and as a serious focus for research and development.

The dream of manned space travel to the Moon and life on the Moon continues to inspire in reality. It is indicative of humankind's insatiable curiosity, our striving to look beyond boundaries, restrictions, and limits. The current re-emergence of the Moon across all media and disciplines is subliminally fueling the public imagination once again and might be preparing humankind for the dawn of a new space Age.

The future was never closer than it is today. We're just a mind step away. Sooner or later, without a doubt, we will return to the Moon.

fig. 330

290

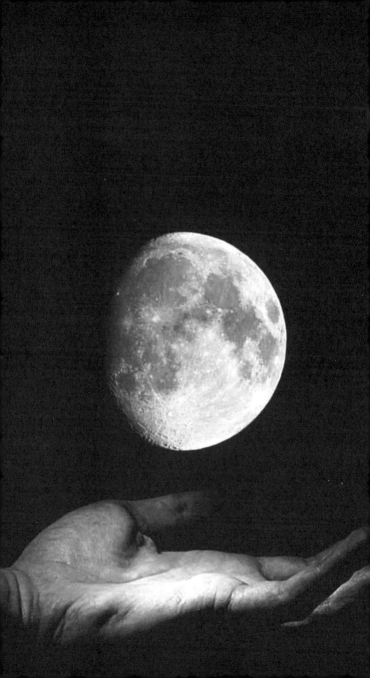

IMAGE SOURCES

fig. 1 Full Moon photograph. Author: Gregory H. Revera. Source: Wikimedia Commons

fig. 2 Artist's depiction of the impact of a body the size of the moon impacting a planet the size of Mercury. Author: NASA. Source: Wikimedia Commons

fig. 3 Detail of fresco showing Anaxagoras. National and Kapodistrian University of Athens. Author: Eduard Lebiedzki, after a design by Carl Rahl, circa 1888. Source: Wikimedia Commons

fig. 4 Marble and alabaster bust of Aristotle. Roman copy after a Greek bronze original by Lysippos from 330 BC. National Museum of Rome, Palazzo Altaemps. Photo: Jastrow, 2006. Source: Wikimedia Commons

fig. 5 Engraving of Claudius Ptolemy (AD c100–170) being guided by the muse Astronomy – Margarita Philosophica by Gregor Reisch, published in 1508. Source: Wikimedia Commons

fig. 6 Portrait of Greek historian Plutarch from a 1565 translation of Jacques Amyot of Plutarch's Parallel Lives. Source: Wikimedia Commons

fig. 7 A 17th-century fictional portrait of Lucian of Samosata. Engraving of the English painter William Faithorne. Source: Wikimedia Commons

fig. 8 *The True History* by Lucian. Illustration by Ruth Cobbs. Source: "Lands of Desire" by Ruth Cobbs in Chatterbox (Children's Annual), published by Wells Gardner, Darton & Co., London 1926

fig. 9 Gustave Dore's depiction of Lucian's *True History*, circa. 1868. Source: Wikiart. Visual Art Encyclopedia

fig. 10 Statue of Ferdovsi in Rome, Italy. A gift from the city of Teheran to the city of Rome. Source: Ordway Collection/Space & Rocket Center

fig. 11 A symbol of Islam, the start and crescent. Image created by Kbolino. Source: Wikipedia

fig. 12 Albrecht Dürer, *The Madonna on the Crescent,* ca. 1510. Source: thewhitereview.org

fig. 13 "An Astrologer Casting a Horoscope" from Robert Fludd's *Utriusque Cosmi Historia,* Oppenheim, 1617. Source: Wikipedia

fig. 14 Ecipse of Christopher Columbus. Engraving in *Astronomie Populaire* from 1879, p. 231 fig. 86. Source: Wikimedia Commons

fig. 15 *The Great Comet of 1577,* Woodcut by Jiri Daschitzsky in: Petrus Codicillus a Tulechova, *Von einem Schrecklichen und Wunderbahrlichen Cometen so sich den Dienstag nach Martini M. D. Lxxvij. Jahrs am Himmel erzeiget hat.* Source: Wikimedia Commons

fig. 16 Imaginative painting by H.J. Detouche from 1754 showing Galileo Galilei displaying his telescope to Leonardo Donato. Source: Wikimedia Commons

fig. 17 Portrait of Galileo Galilei from *Popular Science Monthly* Volume 78, 1911. Source: Wikimedia Commons

fig. 18 Galileo's sketches of the moon from *Sidereus Nuncius,* published in March 1610. Source: Wikimedia Commons

fig. 19 Map of the Moon from *Selenographia, dive Lunae descriptio* by Johannes Hevelius, 1647. Source: Wikimedia Commons

fig. 20 Lunar maps by Giovanni Battista Riccioli and Francesco Maria Grimaldi in *Almagestum novum,* Bologna, 1651. Source: Florence, Istituto e Museo di Storia della Scienza, MED 2165, plates I and VI, p. 204

fig. 21 John Vanderlyn, *The Landing of Columbus,* Oil on Canvas, 1847. Source: Wikimedia Commons

fig. 22 Portrait engraving of Johannes Kepler by Hugo Bürkner, 1854. Source: The Granger Collection, New York

fig. 23 Kepler's Platonic solid model of the Solar system from *Mysterium Cosmographicum,* 1596. Source: Wikimedia Commons

fig. 24 Frontispiece and title page of the first edition of Godwin's *Man in the Moone* published in 1638. Source: Wikimedia Commons

fig. 25 Title page of John Wilkin's *The Discovery of a World in the Moone,* 1638. Source: Ordway Collection/Space & Rocket Center

fig. 26 Rendering from a 1710 edition of Cyrano de Bergerac's lunar tale. Source: Ordway Collection/Space & Rocket Center

fig. 27 Illustration of Wan Hoo and his space vehicle. Source: United States Civil Air Patrol

fig. 28 Title page of Daniel Deffoe's anonymously published *The Consolidator,* 1705. Source: Ordway Collection/Space & Rocket Center

fig. 29 Original Engraving for William Hogarth's *Some Principal Inhabitants of the Moon,* ca. 1724. Source: william-hogarth.com

fig. 30 Frontispiece for Samuel Bruent's *A Voyage to Cacklogallinia,* 1727. Source: Ordway Collection/Space & Rocket Center

fig. 31 First test flight with an aerostat at Annonay in 1783. Originally published in Paris between 1890 and 1900. Source: Library of Congress

fig. 32 Illustration by G. Cruikshank for *The Travels and Surprising Adventures of Baron Munchhausen,* 19th century. Source: forgottenfutures.co.uk

fig. 33 Scene from 1943 German Film *The Adventures of Baron Munchausen* directed by Josef von Báky

fig. 34 Illustration of Maximilian Hell during his stay at Vardo in 1769 to observe the transit of Venus. Source: Hamy, Alfred, *Galerie illustrée de la Compagnie de Jésus,* Paris

fig. 35 Caspar David Friedrich, *Moon,* ca. 1819. Source: The Metropolitan Museum of Art

fig. 36 Illustration of Moon music. Source: New York Times. Credit: Bernd Brunner, *Moon. A Brief History,* Yale University Press, 2010. Source: New York Times.

fig. 37 Sheet music from Jean Jobert's reprint from 1932 of Claude Debussy's *Suite Bergamasque,* Paris. Source: www.imslp.org

fig. 38 Wilhelm Beer and Johan Heinrich von Mädler, *Kappa Selenographica,* 1834. Source: SLUB Dresden

fig. 39 Photo of the 1827 edition of George Tucker's book *A Voyage to the Moon: With Some Account of the Manners and Customs, Science and Philosophy, of the People of Morosofia, and other Lunarians.* By Joseph Atterley. Source: L.W. Currey, Inc.

fig. 40 Portrait of a man-bat (Vespertilio-homo), from an edition of the moon series published in Naples, Italy. Courtesy of the New York Public Library. Source: Wikimedia Commons

fig. 41 Great Moon Hoax lithograph of „ruby amphitheater" for *The Sun,* August 28, 1835. Source: Wikimedia Commons

fig. 42 Yan Dargent's illustration about Edgar Allan Poe's *The Unparalleled Adventure of One Hans Pfaal* for *Jules Verne's Edgar Poe et ses oeuvres,* 1864. Source: Wikimedia Commons

fig. 43 One of the first ever pictures of the moon taken by Dr. J. William Draper of New York, 1840. Credit: J.W. Draper/Stringer

fig. 44 James Hall Nasymth, *Normal Lunar Crater, Plate XXI.* Source: archive.org

fig. 45 James Hall Nasymth, *Normal Lunar Crater, Plate I.* Source: archive.org

fig. 46 James Hall Nasymth, Drawing of a crater on the surface of the moon, between 1856–1890. Source: Wikimedia Commons

fig. 47 Photo of Thomas Dickert's Model of the Moon, Field of Columbian Museum, Chicago, 1894. Source: The Oddment Emporium

fig. 48 Arrival of the projectile at Stone's Hill from an illustrated edition of Jules Verne's *From the Earth to the Moon* by permission of Jerry Woodfill, 1886. Source: NASA

fig. 49 Engraving by Émile Bayard for *Around the Moon* in Jules Verne, *Voyages extraordinaires,* Éd. Pierre-Jules Hetzel, 1870. Source: Wikimedia Commons

fig. 50 Illustration from *The Brick Moon* by Edward Everett Hale published in The Atlantic Monthly, 1869. Source: Wikipedia

fig. 51 Illustration from André Laurie's *The Conquest of the Moon,* 1888. Credit: Bernd Brunner, *Moon. A Brief History,* Yale University Press, 2010. Source: New York Times

fig. 52 Title illustration from G. Le Faure and H. de Graffigny's *Extraordinary Adventures of a Russian Scientist,* 1889

fig. 53 Cover photo of 1890 edition of Robert Cromie, *A Plunge into Space*

fig. 54 Illustration from Robert Cromie's *A Plunge into Space,* 1890

fig. 55 Konstantin Tsiolkovsky in his study surrounded by models of his rocket designs, 1924. Reproduction from V. Dellin's book *Tsiolkovsky,* Molodaia gvardiia, 2005. Source: www.arttattler.com

fig. 56 Photo of first edition of H.G. Well's book *The First Men in the Moon.* Source: imgarcade.com

fig. 57 Illustration from Amazing Stories reprint of H.G. Well's *The First Men in the Moon*

fig. 58 Screenshot from George Méliès's *Le Voyage dans la Lune* (A Trip to the Moon), 1902. Source: Roger-Viollet

fig. 59 Production still from Georges Méliès's *Le Voyage dans la Lune* (A Trip to the Moon), 1902. Source: Wikimedia Commons

fig. 60 Sketch by George Méliès for *Le Voyage dans la Lune* (A Trip to the Moon), 1902. Source: The Red List

fig. 61 Screenshot from Méliès's *Le Voyage dans la Lune* (A Trip to the Moon), 1902. Source: The Red List

fig. 62 Photo of a half moon by Maurice Lœwy and Pierre Henri Puiseux, 1894. Source: Wikimedia Commons

fig. 63 First flight of the Wright Flyer I, December 17, 1903, Orville piloting, Wilbur running at wingtip. Source: Library of Congress

fig. 64 Konstantin Tsiolkovsky with his hearing device in his studio. Source: Andrei Nakov, "Quelques éléments d'une convergence significative entre Malewicz et Ciolkovski," in *La conquête de l'air : Une aventure dans l'art du XXème siècle,* Toulouse: Les Abattoirs, 2002

fig. 65 Robert Esnault-Pelterie on Rep 1 tractor monoplane, 1907. Source: L.E. Opdycke

fig. 66 Photo of 1915 edition of the book *The Man Who Rocked the Earth.* Source: L.W. Currey, Inc.

fig. 67 Illustration by Hans Baluschek of the Man in the Moon in Gerdt von Bassewitz's *Journey to the Moon,* 1918. Source: Wikimedia Commons

fig. 68 Machine gun mounted on a parasol monoplane, 1916. Bibliothèque nationale de France, département Estampes et photographie, EI-13 (474). Source: Wikimedia Commons

fig. 69 Lunar Orbti Redezvous Diagram, 1962. Source: NASA

fig. 70 Dr. Robert H. Goddard and a liquid oxygen-gasoline rocket at Auburn, Massachusetts, 1926. Author: Esther C. Godard. Source: NASA

fig. 71 Photo of Herman Oberth's book *Die Rakete zu den Planetenräumen,* 1922

fig. 72 Max Valier in rocket-car, 1929. Source: Bundesarchiv

fig. 73 Poster illustration by Hans & Botho von Römer for Max Valier's lecture *Advance into Space* (Vorstoss in den Weltraum), ca. 1930. Source: artnet.com

fig. 74 Photo of 1925 edition of Otto Willi Gail's book *Der Schuß ins All.* Source: deacademic.com

fig. 75 Cover for Otto Willi Gail's *Mit Raketenkraft ins Weltenall – Vom Feuerwagen zum Raumschiff,* 1928. Source: JF Ptak Science Books

fig. 76 Theatrical release poster for Fritz Lang's *Woman in the Moon,* 1929. Source: Wikipedia

fig. 77 Screenshot from Fritz Lang's *Woman in the Moon,* 1929. Source: TV Bomb

fig. 78 Production still from Fritz Lang's *Woman in the Moon,* 1929. Source: Cinefantastique

fig. 79 Details of rocket from Fritz Lang's *Woman in the Moon,* 1929. Source: www.fanboy.com

fig. 80 Details of rocket from Fritz Lang's *Woman in the Moon,* 1929. Source: www.fanboy.com

fig. 81 Details of rocket from Fritz Lang's *Woman in the Moon,* 1929. Source: www.fanboy.com

fig. 82 Cover illustration for 1927 edition of *Die Rakete.* Source: Wikimedia Commons

fig. 83 Historic view of the Verein für Raumschiffahrt with early version or model for the minimum rocket Mirak, 1930. Left to right: Rudolf Nebel, Franz Ritter, Unknown, Kurt Heinisch, Unknown, Herman Oberth, Unknown, Klaus Riedel, Wernher von Braun, Unknown. Source: Library of Congress

fig. 84 Rudolf Nebel and Wernher von Braun carrying test rockets, 1932 . Source: www.v2rocket.com

fig. 85 The Single Men's Unemployed Association parading to Bathurst Street United Church. Toronto, Canada, ca. 1930. Library and Archives Canada, C-029397. Source: Wikipedia.

fig. 86 Cover illustration by Dick Calkins for *Buck Rockers,* ca. 1930s. Source: blastr.com

fig. 87 Cover of *Astounding Stories* with article by Willey Ley, 1937. Source: Vinylz Art

fig. 88 Wernher von Braun at Peenemünde, 1941. Source: Bundesarchiv

fig. 89 Damage Caused by V-2 Rocket Attacks in Britain, 1945. Imperial War Museum, HU 88803. Source: Wikipedia

fig. 90 Prisoners at the Concentration Camp Mittelbau-Dora building the V-2 Rocket, 1944. © ullstein bild / Walter Frentz

fig. 91 Wernher von Braun with model of rocket for US Military, 1940s. Source: NASA

fig. 92 Von Braun's German rocket scientist team at Fort Bliss, Texas, 1946. Source: NASA

fig. 93 The test subject, a rhesus monkey named Sam, is seen encased in a model of the Mercury fiberglass contour couch, 1959. Source: NASA

fig. 94 Squirrel monkey "Baker" rode a Jupiter IRBM into space and back in 1959. Source: NASA

fig. 95 Cover of Willy Ley's book *The Conquest of Space* with paintings by Chesley Bonestell, 1949. Source: Space Art

fig. 96 Painting of lunar landscape by Chesley Bonestell, 1949. Source: sciencefictional.net

fig. 97 Cover illustration by Chesley Bonestell for *Collier's Magazine,* March, 1952. Source: Dreams of Space

fig. 98 Illustration by Chesley Bonestell for *Collier's Magazine,* March, 1952. Source: Dreams of Space

fig. 99 Rose Wyler, *Exploring Space,* 1958. Source: NASA

fig. 100 Major Jet's Magic Paint Set for breakfast cereal Sugar Jets, 1952. Source: Dreams of Space

fig. 101 Spaceman, Macy's Thanksgiving Day Parade, 1952. Source: Bettman/CORBIS

fig. 102 Spaceman, Macy's Thanksgiving Day Parade, 1952. Source: CSU Archives/ Everett Collect/REX

fig. 103 *Space Happy Coloring Book,* 1953. Source: Pulp Covers

fig. 104 *The Complete Book Of Space Travel,* Albro Gaul, 1956. Source: www.ianclaridge.co.uk

fig. 105 Illustration for Chinese Space Program, 1962. Source: www. chineseposters.net

fig. 106 Cover and half title of the first edition of Arthur C. Clarke's *Prelude to Space,* 1951. Source: lakdiva.org/ clarke

fig. 107 The official television cast photo for the Space Patrol from the original press packet, 1953. Author: Mike Moser Productions. Source: Wikipedia

fig. 108 Space Patrol Rocket on display in large crowd. Source: Space Patrol Collection of Warren Chaney Productions, Inc.

fig. 109 Theatrical release poster for the film *Destination Moon,* 1950. Source: Pinterest

fig. 110 Screenshot the film *Destination Moon,* 1950. Source: Air & Space Smithsonian

fig. 111 Matte painting by Chesley Bonestell for the film *Destination Moon,* 1950. Source: Mark Cotta Vaz & Craig Barron, The Invisible Art. The Legends of Movie Matte Painting, 2002

fig. 112 Front cover art for the Tintin book *Explorers on the Moon,* 1954. Author: Hergé Foundation. Source: Wikipedia

fig. 113 Illustration from the Tintin book *Explorers on the Moon,* 1954. Author: Hergé Foundation. Source: Wikipedia

fig. 114 Screenshot of Walt Disney in front of Moon model for the Disney film *Man and the Moon,* 1954. Source: www.disneyandmore-movies.blogspot.de

fig. 115 Walt Disney in his office with a model of the Tomorrowland rocket, 1954. Source: www.disneyandmore-movies.blogspot.de

fig. 116 Walt Disney in his office holding a model spaceship, 1954. Source: www. disneyandmoremovies. blogspot.de

fig. 117 Walt Disney and Wernher von Braun with rocket and spaceship models, 1954. Source: www.disneyandmore-movies.blogspot.de

IMAGE SOURCES

fig. 118 Official emblem of the International Geophysical Year 1957–1958. Source: The National Academies

fig. 119 Photograph of the launch of Sputnik 1 on October 4, 1957

fig. 120 Photograph of Laika in her flight harness, 1957

fig. 121 Photograph of Laika in Sputnik 2, 1957

fig. 122 Official first emblem of National Aeronautics and Space Administration (NASA), 1958. Source: NASA

fig. 123 Depiction of Project Horizon lunar outpost as it would appear by late 1965, 1958. Author: US Army. Source: www. astronautix.com

fig. 124 Cover of *A Study of Lunar Research Flights* – Volume I, 1959. Author: Armour Research Foundation. Source: Wikipedia

fig. 125 Lunar Hilton reservation request. Author: The Hospitality Industry Archives, Conrad Hilton College, University of Houston. Source: BBC

fig. 126 Space Law. A Bibliography, 1958. Source: United Nations

fig. 127 Photograph of Luna 2 Soviet moon probe. Source: NASA

fig. 128 The first image of the far side of the Moon, taken by Luna 3, October 7, 1959. Source: NASA

fig. 129 Theatrical release poster for the film *12 to the Moon,* 1960. Author: Columbia Pictures. Source: www. wrongsideoftheheart. com

fig. 130 Yuri Gagarin in his flight harness, 1960s. Source: www. afflictor.com

fig. 131 Yury Gagarin and Soviet leader Nikita Khrushchev a few days after Gagarin's historic flight, 1961. Source: RFE/RL

fig. 132 Alan Shepard in capsule aboard Freedom 7 before launch, 1961. Source: NASA

fig. 133 John F. Kennedy speaks at Rice University, 1962. Author: Unknown. Source: NASA

fig. 134 Apollo insignia, 1962. Source: NASA

fig. 135 Apollo of the Belvedere. Author: Livioandronico2013. Source: Wikimedia Commons

fig. 136 Model depicting an early Apollo lunar lander concept, 1963. Source: NASA

fig. 137 Model of lunar module with astronaut against imaginary lunar backdrop. Source: NASA

fig. 138 Cover of *Fantastic Four,* Volume 1, Issue 13, April 1963. Source: marvel.wikia.com

fig. 139 Paul Calle, *Power,* 1963. Source: NASA Art Program

fig. 140 Photograph of first space walk by Alexey Leonov, 1965. Source: BBC

fig. 141 Photograph of first space walk by Ed White 1965. Source: NASA

fig. 142 Committee on the Peaceful Use of Outer Space, United Nations Headquarters, New York, 1966. Source: United Nations

fig. 143 Photograph of first space walk by Ed White 1965. Source: NASA

fig. 144 Photograph of party at Andy Warhol's Silver Factory, 1960s. Author: Unknown. Source: www.basisdesign.com

fig. 145 Haus-Rucker-Co, *Oase Nr. 7,* documenta 5, 1972. Photo: Brigitte Hellgoth/Archiv Zamp Kelp

fig. 146 Walter Pichler, *Small Room* (Prototype 4), 1967

fig. 147 Model of *Living Pod* by Archigram, 1966. Source: Archigram.net

fig. 148 Coop Himmelblau, Villa Rosa, 1968. Photo: Michael Pilz. Source: Coop Himmelblau

fig. 149 Coop Himmelblau, Villa Rosa, 1968. Photo: Felix Waske. Source: Coop Himmelblau

fig. 150 Coop Himmelblau, Villa Rosa, 1968. Source: Coop Himmelblau

fig. 151 Archigram's *Walking City* by Ron Herron, 1964. Source: Archigram.net

fig. 152 Detail of Archigram's *Walking City* by Ron Herron, 1964. Source: Archigram.net

fig. 153 *Jersey Corridor* project by Peter Eisenman and Michael Graves, 1966. Source: www.dwell.com

fig. 154 Installation view of Nam June Paik's *Moon Is the Oldest TV,* 1965. Source: www.koreatimes.co.kr

fig. 155 Installation view of Nam June Paik's *Moon Is the Oldest TV,* 1965. Source: www.koreatimes.co.kr

fig. 156 Adaptation of the original 1966 cover illustration of Tomi Ungerer's book *Moon Man.* Source: www.tribecafilm.com

fig. 157 Various book covers of Jerome Beatty's *Matthew Looney* series, 1960s

fig. 158 Luna 9 photograph from the surface of the Moon, 1966. Source: The Center for Computational Aesthetics

fig. 159 Lunar orbiter 1 first ever photograph of the Earth from the surface of the Moon, 1966. Source: NASA

fig. 160 Stewart Brand's pin *Why haven't we seen a photograph of the whole Earth yet?,* 1966. Source: UCLA

fig. 161 Cover of first edition of *The Whole Earth Catalog*, 1968. Source: UCLA

fig. 162 Copy of the Outer Space Treaty, 1967. Source: www.state.gov/t/ac/trt/5181.htm

fig. 163 The Apollo 1 crew expressed their concerns about their spacecraft's problems by presenting this parody of their crew portrait to ASPO manager Joseph Shea on August 19, 1966. Source: NASA

fig. 164 Official Apollo 1 patch, 1967. Source: NASA

fig. 165 Fred Freeman, *Saturn Blockhouse*, Acrylic on canvas, 1968. Source: NASA Art Program

fig. 166 Apollo 8 mission profile, 1968. Source: NASA

fig. 167 Original member card of Pan Am's First Moon Flights Club, 1968. Source: www.backstoryradio.org

fig. 168 Earthrise photo taken by Apollo 8 crew member Bill Anders on December 24, 1968. Source: NASA

fig. 169 Original cover of Buckminster Fuller's *Operating Manual for Spaceship Earth*, 1968. Source: www.accesstoexcellence.co.uk

fig. 170 Theatrical release poster for the film *2001: A Space Odyssey*, 1968. Source: Wikipedia

fig. 171 Cover art for David Bowie's *Space Oddity*, 1968. Source: Amazon

fig. 172 Theatrical poster for the film *Moon Zero Two*, 1969. Source: Wikipedia

fig. 173 Apollo 11 Insignia, 1969. Source: NASA

fig. 174 Saturn V carrying Apollo 11 rises past the launch tower camera, 1969. Source: NASA

fig. 175 Crowd watching the take off of Apollo's Saturn rocket, 1969. Source: NASA

fig. 176 Jack Perlmutter, *Moon, Horizon, and Flowers* (Rocket Rollout), Oil-on-canvas, 1969. Source: NASA Art Program

fig. 177 Robert Rauschenberg, *Stoned Moon*, Lithograph, 1969. Source: NASA Art Program

fig. 178 Apollo 11 Lunar Module Eagle in landing configuration in lunar orbit from the Command and Service Module Columbia, 1969. Source: NASA

fig. 179 Neil Armstrong descends a ladder to become the first human to step onto the surface of the Moon, 1969. Source: NASA

fig. 180 Buzz Aldrin on the Moon, 1969. Source: NASA

fig. 181 Buzz Aldrin's bootprint on the lunar surface, 1969. Source: NASA

fig. 182 The plague left on the letter of Eagle, 1969. Source: NASA

fig. 183 Gold replica of an olive branch left on the Moon, 1969. Source: NASA

fig. 184 The crew of Apollo 11 in quarantine after returning to Earth, visited by Richard Nixon, 1969. Source: NASA

fig. 185 Pictures of the Giant Leap Tour, Parade in New York City, 1969. Source: NASA.

fig. 186 Pictures of the Giant Leap Tour, Parade in New York City, 1969. Source: NASA.

fig. 187 Ferdinand Kriwet, *Apollo Amerika,* Suhrkamp, 1969. Source: Jan Wenzel

fig. 188 Official crew insignia for Apollo 12, 1969. Source: NASA

fig. 189 Astronaut Pete Conrad studies the Surveyor 3 spacecraft; the Lunar Module, Intrepid, can be seen in the top right of the picture, 1969. Source: NASA

fig. 190 Official crew insignia for Apollo 13, 1970. Source: NASA

fig. 191 The Moon photographed by the Apollo 13 crew from their Lunar Module "life boat" as they passed by, 1970. Source: The Apollo Image Gallery

fig. 192 Apollo 13 successful splashdown in the South Pacific, 1970. Source: NASA

fig. 193 Official crew insignia for Apollo 14, 1971. Source: NASA

fig. 194 Alan Shepard poses next to the American flag on the Moon during Apollo 14, 1971. Source: NASA

fig. 195 Official crew insignia for Apollo 15, 1971. Source: NASA

fig. 196 Apollo 15 Commander Dave Scott during geology training in New Mexico, 1971. Source: NASA

fig. 197 Lunar Module Pilot Jim Irwin seen with the Lunar Roving Vehicle, with Mount Hadley in the background, 1971. Source: NASA

fig. 198 Apollo 15 Lunar Module Pilot James Irwin salutes the U.S. flag, 1971. Source: NASA

fig. 199 Fallen Astronaut sculpture on the Moon, 1971. Source: NASA

fig. 200 Official crew insignia for Apollo 16, 1971. Source: NASA

fig. 201 Astronauts John Young and Charles Duke participate in geology training at the Rio Grande Gorge, New Mexico, 1971. Source: Apollo Lunar Surface Journal

fig. 202 Charles Duke stands in the shadow of Shadow Rock 1971. Source: NASA

fig. 203 The view from the side of Stone Mountain, 1971. Source: NASA

fig. 204 Official crew insignia for Apollo 17, 1972. Source: NASA

fig. 205 Gene Cernan aboard the Lunar Rover during the first EVA of Apollo 17, 1972. Source: NASA

fig. 206 Plaque left on the Moon by Apollo 17 crew, 1972. Source: NASA

fig. 207 Astronaut Harrison Schmitt standing next to boulder, 1972. Source: NASA

fig. 208 Blue Marble photograph of the Earth taken on December 7, 1972, by the crew of the Apollo 17 spacecraft en route to the Moon. Source: NASA

fig. 209 The Apollo Genesis Rock. Source: NASA

fig. 210 U.S. Air Force Boeing dropping bombs over Vietnam, 1972. Source: National Museum of the US Air Force

fig. 211 Igor Koslov, Section of a lunar base living quarter for two persons, 1971. Source: Volume Magazine

fig. 212 IBM technology that brought men to the Moon. Source: Wikipedia

fig. 213 Clyde Drexler with AVIA Compression Chamber shoes, 1980s. Source: NBA

fig. 214 Signed poster of the Moonwalkers by Ron Lewis, 1986. Source: Astronaut Central

fig. 215 Front cover of Buzz Aldrin's book *Return to Earth*, Random House, 1973. Source: Amazon

fig. 216 Alan Bean in front of his painting easel at his art studio in Houston, 2008. Credit: Carolyn Russo. Source: National Air and Space Museum, Smithsonian Institution

fig. 217 Front cover of the first edition of Norman Mailer's *Of A Fire On the Moon*, 1970. Source: Wikipedia

fig. 218 Front cover of Ursula K. Le Guin's book *The Lathe of Heaven*, 1971. Source: Wikipedia

fig. 219 Poster depicting *Dr. Who on the Moon*, 1973. Source: BBC

fig. 220 Cover art for Pink Floyd's album *Dark Side of the Moon*, 1973. Source: www.dragoart.com

fig. 221 Cover of Isaac Asimov's book *The Tragedy on the Moon*, 1973

fig. 222 Official L5 Emblem, 1975. Source: National Space Society

fig. 223 Diagram of L5 settlement plan. Source: National Space Society

fig. 224 Cover of Bill Kaysing and Randy Reid's book *We Never Went to the Moon*, 1976

fig. 225 Buzz Aldrin and Neil Armstrong in NASA's training mockup of the Moon. Source: NASA

fig. 226 First picture of the Earth and Moon in a single frame, 1977. Source: NASA

fig. 227 Cover of golden Voyager Golden Record, 1977. Source: NASA

fig. 228 Leandro Katz, *Lunar Alphabet I,* Courtesy of the artist. Source: Leandro Katz

fig. 229 Leandro Katz, *Lunar Alphabet I,* Courtesy of the artist. Source: Leandro Katz

fig. 230 Theatrical release poster for *Capricorn One,* Warner Bros. 1978, Source: www.impawards.com

fig. 231 Theatrical release poster for James Bond *Moonraker,* 1979. Source: United Artists

fig. 232 Cover of Maurice Chatelain's book *Our Ancestors Came From Outer Space,* 1978

fig. 233 Promotional flyer for *Space Invaders,* 1978: Source Arcade Museum

fig. 234 MTV Video Music Awards Moon Man. Source: MTV

fig. 235 Overview of part of the Space Camp/ Space Academy training area, 1982. Source: U.S. Space & Rocket Center

fig. 236 Cover art for the R.E.M. single *Man on the Moon,* 1982

fig. 237 Screenshot of Michael Jackson performing the moonwalk, ca. 1983

fig. 238 Logo of Dennis Hope's *Lunar Embassy,* 1980. Source: Lunar Embassy

fig. 239 Cover of Stanislaw Lem's book *Peace on Earth,* 1987

fig. 240 Promotional flyer by Keith Haring for André Heller's *Luna Luna Park,* 1986. Source: Ketterer Kunst

fig. 241 Andy Warhol, *Moonwalk 1,* Silkscreen on paper, 1987. Source: NASA Art Program

fig. 242 Cover of J.G. Ballard's book *Memories of the Space Age,* 1988.

fig. 243 Cover of Paul Auster's book *Moon Palace,* 1989

fig. 244 Theatrical release poster for the documentary film *For All Mankind,* 1989. Source: Wikipedia

fig. 245 Illustration of inflatable habitat for the Moon. Source: NASA

fig. 246 A jar containing 1 of JSC-1A (of Lunar Regolith), 1994. Author: Arnhold Reinhold. Source: Wikipedia

fig. 247 Cover of Jim Lovell & Jeffrey Kluger's book *Lost Moon,* 1994

fig. 248 Theatrical release poster for the film *Apollo 13,* 1995. Source: www.spaceacts. com

fig. 249 Clementine Mission Uncontrolled Image Mosaic, 1995. Source: NASA

fig. 250 Theatrical release poster for the film *Star Trek: First Contact*, 1996

fig. 251 Cover of *Euromoon 2000* brochure by the European Space Agency, 1990s. Source: Koninklijke Bibliotheek

fig. 252 Illustration from *Justice League of America*, 1997. Author: DC Comics

fig. 253 Screenshot from the film *Truman Show*, 1998. Source: Paramount Pictures

fig. 254 Transient Lunar Phenomena near Aristarchus crater. Source: Globalove Think Tank

fig. 255 Screenshot from Futurama's *The Series has Landed*, 1999. Author: 20th Century Fox

fig. 256 Theatrical release poster for the film *Eyes Wide Shut*, 1999. Author: Warner Bros

fig. 257 Aleksandra Mir, *First Woman on the Moon*, Casco Projects, 1999. Courtesty of the artist

fig. 258 Rendering of John Mankin's *Habot Lunar Habitat Walker* by Pat Rawlings, 2000. Courtesy: John Mankins, NASA, Neville Marzwell, Jet Propulsion Laboratory

fig. 259 Website of Moon Estates, 2001. Source: Moon Estates

fig. 260 Rendering of Hans-Jürgen Rombaut's *Lunar Hotel*. Source: Hans-Jürgen Rombaut

fig. 261 Rendering for ESA's *Aurora Space Exploration Programme*, 2007. Source: ESA

fig. 262 Poster for the documentary *Conspiracy Theory: Did We Really Land On the Moon?* Source: Fox Television

fig. 263 Poster for the documentary *A Funny Thing Happened on the Way to the Moon*, 2001. Source: Wikipedia

fig. 264 Poster for the mockumentary *Dark Side of the Moon*, 2002

fig. 265 An illustration of a red house on the Moon for Mikael Genberg. Source: Sara Medina Lind

fig. 266 William Kentridge, *Journey to the Moon*, 2003. Courtesy of the Artist. Source: www.gallerytpw.ca

fig. 267 George W. Bush during State of the Union Speech with lunar scape in background, 2004. Source: NASA/ Enjoy Space

fig. 268 Rendering of SMART-1 is travelling to the Moon using a new solar-electric propulsion system. Source: ESA/ J.Huart

fig. 269 Rendering of Virgin Galactic SpaceShip Two. Source: Virgin Galactic

fig. 270 Tom Sachs, *Crawler* (1:25 scale), foamcore, thermal adhesive, wood, 118 × 103 × 107 in., 2003. Courtesy of the artist

fig. 271 Tom Sachs, *U.S. Space Suit*, ink on paper, 11 × 8½ in., 2005. Courtesy of the artist

fig. 272 Photo from Laurie Andreson's performance *The End of the Moon*, 2005

fig. 273 Logo of clothing label Billionaires Boys Club. Source: www. bbicecream.com

fig. 274 Interior view of Billionaire Boys Club flagship store in New York City. Source: www. freshnessguide.com

fig. 275 Illustration of possible permanent base on the Moon, 2006. Source: NASA

fig. 276 A piece of moon rock on dipslay at the Dutch national museum has been revealed to be a piece of petrified wood after an investigation. Source: AP.

fig. 277 Pictures of Tom Sachs's exhibition *Space Program* at Gagosian Gallery, 2007. Courtesy of the Artist. Source: Tom Sachs

fig. 278 Pictures of Tom Sachs's exhibition *Space Program* at Gagosian Gallery, 2007. Courtesy of the Artist. Source: Tom Sachs

fig. 279 Emblem of the Chinese Lunar Exploration Program. Source: Wikipedia

fig. 280 Logo of Google Lunar X Prize. Source: www.lunar.xprize.org

fig. 281 Picture of possible ruins on the Moon as claimed by Ken Johnston in 2007. Source: www. andnooneknows.com

fig. 282 View of Shackleton Crater on the Moon. Source: NASA

fig. 283 Vincent Fournier, Vehicle Assembly Building, Launch Control Center on the right hand side, J.F.K. Space Center (NASA), Florida, USA, 2011. Courtesy of the artist

fig. 284 Vincent Fournier, Baikonur City # 2 (Unknown Fields Division), The International Space School VN Chelomey, Kyzlorda, Kazakhstan, 2011. Courtesy of the artist

fig. 285 Vincent Fournier, Mars Desert Research Station # 4 Mars Society, San Rafael Swell, Utah, USA, 2008. Courtesy of the artist

fig. 286 Interior view of Chandrayaan 1 laboratory in India, 2008. Source: Chandrayaan-i.

fig. 287 Agnes-Meyer Brandis, *The Moon Goose Experiment,* Island of the Sacred Scarab, launch pad, in the River Ob, near Novosibirsk, RU, 1st Aug. 2008. Photo: Agnes Meyer-Brandis, VG-Bildkunst

fig. 288 *Earth–Moon–Earth* (Moonlight Sonata Reflected from the Surface of the Moon) by Katie Paterson, 2007. Disklavier grand piano. Installation view, Modern Art Oxford, 2008. Photo: Andy Keate 2008. Courtesy of the artist

fig. 289 Rendering of Lunar Reconnaissance Orbiter, 2009. Source: NASA

fig. 290 Rendering on how lunar solar energy reaches the Earth, 2008. Source: Shimizu Corporation

fig. 291 Rendering of the solar belt along the lunar equator, 2008. Source: Shimizu Corporation

fig. 292 Theatrical release poster for the film *Moon* by Duncan Jones, 2009. Source: Source: Pinterest

fig. 293 Lunar Hilton hotel room key. Author: The Hospitality Industry Archives, Conrad Hilton College, University of Houston. Source: BBC

fig. 294 Alicia Framis performing *Lost Astronaut* while following Marina Abramovic's instruction to read an entire issue of the *New York Times* backwards, 2009. Courtesy of the artist.

fig. 295 Installation view of Alicia Framis's *Moon Life Concept Store* in Utrecht, Netherlands, 2012. Courtesy of the artist

fig. 296 Leonid Tishkov's Private Moon during Linz09 European Capital of Culture, 2009. Author: Leonid Tishkov. Source: Linz09. Courtesy of the artist

fig. 297 President Barak Obama at Kennedy Space Center in 2010. Source: NASA

fig. 298 Screenshots of Itchy and Scratchy from *The Simpsons* episode Moe Letter Blues, 2010. Source: Fox

fig. 299 Screenshots of Itchy and Scratchy from *The Simpsons* episode Moe Letter Blues, 2010. Source: Fox

fig. 300 Screenshot of the film *Despicable Me* showing the super villain Gru holding the Moon in his hand, 2010. Source: Universal

fig. 301 Rendering of *Lunar Sphere House* by Royal Haskoning Architects, 2010

fig. 302 Screenshot from the film *Transformers: Dark of the Moon*, 2011. Source: Paramount Pictures

fig. 303 Theatrical release poster for the film *Apollo 18* by Gonzalo López-Gallego, 2011

fig. 304 Fake photograph of swastika on the Moon as part of the marketing campaign for the film *Iron Sky*, 2010. Source: Above Top Secret

fig. 305 Perspective section of the *Stadium International Lunar Olympics* by Brian Harms and Keith Bradley, 2013. Source: Archdaily

fig. 306 Agnes-Meyer Brandis, High Altitude Trainingscamp II, Astronaut Training Method No. XI, Videostill, *Moon Goose Colony* 2011. Photo: Agnes Meyer-Brandis, VG-Bild Kunst

fig. 307 Agnes-Meyer Brandis Analogue Training, Astronaut Training Method No. XVI, Videostill, *Moon Goose Colony* 2011. Photo: Agnes Meyer-Brandis, VG-Bild Kunst

fig. 308 Installation view of *As Good as Moon Rock* by We Colonised the Moon as part of the exhibition Authentic Goods from a Realistic Future, 2012. Courtesy of the artists

fig. 309 Photo from the *Aerospace* series and book Last Launch by Dan Winters, 2012. Courtesy of the artist

fig. 310 Photo from the *Aerospace* series and book Last Launch by Dan Winters, 2012. Courtesy of the artist

fig. 311 Photo from Nelly Ben Hayoun's *Moon Dust Remix,* a project developed as part of a residency in la Gaité Lyrique, Paris. Photo: Vinciane Verguethen. Courtesy of the artist

fig. 312 Photo of the *Space Orchestra* directed by Nelly Ben Hayoun, 2012. Photo: Vinciane Verguethen. Courtesy of the artist.

fig. 313 Katie Paterson, *Second Moon*, 2013. Lunar meteorite, box. Photo: MJC. Courtesy of the artist

fig. 314 Picture from Cristina de Middel's *The Afronauts* series, 2012. Author: Cristina de Middel. Courtesy of the artist

fig. 315 Pictures from Michael Najjar's *Outer Space* series, 2011. Author: Michael Najjar. Courtesy of the artist

fig. 316 Pictures from Michael Najjar's *Outer Space* series, 2011. Author: Michael Najjar. Courtesy of the artist

fig. 317 Renderings of *Second Moon* by Clouds Architecture, 2012. Source: Clouds Architecture. Courtesy of the artists

fig. 318 Screenshot of the online project *Moon Moon* by Olafur Eliasson and Ai Weiwei, 2014. Source: Arte Magazine

fig. 319 Fractal design for a lunar base by Hatem Al Khafaji, 2013. Source: www.behance.net

fig. 320 Installation view of Tomás Saraceno's *In Orbit* at K21 Ständehaus, Düsseldorf, 2013. Courtesy: Tomás Saraceno; Pinksummer contemporary art, Genoa; Tanya Bonakdar Gallery, New York; Andersen's Contemporary, Copenhagen, Esther Schipper Gallery, Berlin. © Photography by Studio Tomás Saraceno, 2013

fig. 321 Luca Galofaro, Moon Bases, 2013

fig. 322 Yutu rover on the lunar surface, photographed by the Chang'e 3 lander, 2013. Source: Chinese National Space Administration/China Central Television

fig. 323 Rendering of lunar base. Foster + Partners works with European Space Agency to 3D print structures on the Moon, 2013. Source: Foster + Partners/ESA

fig. 324 Web promotion for Lunar Catalyst, 2014. Source: NASA

fig. 325 Richard Branson with model of Virgin Moon Hotel, 2014. Source: Dezeen

fig. 326 Photo of the Moon Landing Nike Air Max Lunar90, 2014. Source: Solecollector

fig. 327 *Lunar Surface,* Kimchi and Chips in collaboration with photographer Eunyoung Kim. 2015. Courtesy of the artist. Source: Kimchi and Chips

fig. 328 *A Distant View,* United Visual Artists, Steel, Plywood, India ink, White LED, 2015. Courtesy of the artist. Source: United Visual Artist

fig. 329 Lunar Mission One Logo, 2014. Source: Kickstarter

fig. 330 *Moon in My Hand* by Derlevi, 2011–2015. Source: Derlevi Deviant Art